R711

STEALING WYETH

BOOKS BY BRUCE E. MOWDAY

TRUE CRIME
Stealing Wyeth*
Jailing The Johnston Gang: Bringing Serial Murderers to Justice*

HISTORY
Pickett's Charge: The Untold Story*
J. Howard Wert's Gettysburg
September 11, 1777: Washington's Defeat at Brandywine Dooms
 Philadelphia
Unlikely Allies: Fort Delaware's Prison Community in the Civil War

SPORTS
Richie Ashburn: Why The Hall Not. The Amazing Journey to Cooperstown*

BUSINESS
Selling Your Book*
Life With Flavor: A Personal History of Herr's*
Selling of an Author

FICTION
First Date Homicides

LOCAL HISTORY
Spanning the Centuries: The History of Caln Township
Chester County Mushroom Farming
Six Walking Tours of West Chester
West Chester in Modern Day
Along The Brandywine River
West Chester
Coatesville
Downingtown
Parkesburg

* Published by Barricade Books

STEALING WYETH

BRUCE E. MOWDAY

Published by Barricade Books Inc.
Fort Lee, N.J. 07024
www.barricadebooks.com

Library of Congress Cataloging-in-Publication Data

Names: Mowday, Bruce E., author.
Title: Stealing Wyeth / Bruce E. Mowday.
Description: Fort Lee, N.J. : Barricade Books Inc., [2018] | Includes
 bibliographical references and index.
Identifiers: LCCN 2018047355 (print) | LCCN 2018056478 (ebook) |
 ISBN 9781569808276 (ebook) | ISBN 9781569808269
 (hardcover : alk. paper)
Subjects: LCSH: Art thefts--Pennsylvania--Chadds Ford. |
 Wyeth, Andrew, 1917-2009.
Classification: LCC N8795.3.U6 (ebook) | LCC N8795.3.U6 M69
 2018 (print) | DDC 364.16/2870974814--dc23
LC record available at https://lccn.loc.gov/2018047355

10 9 8 7 6 5 4 3

Manufactured in the United States of America

Dedication
This book is dedicated to the artists of the world,
as they create work that soothes our souls,
and to law enforcement officials,
as they protect us from the evils of the world.

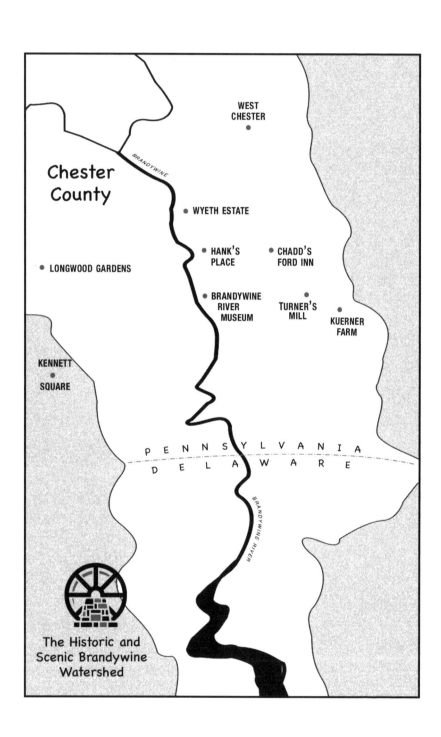

WEST
CHESTER

Chester
County

BRANDYWINE

• WYETH ESTATE

• HANK'S
PLACE

• CHADD'S
FORD INN

• LONGWOOD GARDENS

• BRANDYWINE
RIVER
MUSEUM

TURNER'S
MILL

KUERNER
FARM

KENNETT

SQUARE

P E N N S Y L V A N I A
D E L A W A R E

BRANDYWINE RIVER

The Historic and
Scenic Brandywine
Watershed

CONTENTS

FOREWORD

Walter S. "Terry" Batty, Jr., and John "Jack" Riley
former assistant United States attorneys

As with the others mentioned in *Stealing Wyeth,* a page-turning true crime story, former fellow federal prosecutor Jack Riley and I remember some of the events vividly, but appreciate author Bruce Mowday's reminding us of other details and informing us of what we never knew. Because the events recounted in the book occurred more than 30 years ago, they were recorded on paper, rather than easily — accessible computer files.

Stealing Wyeth is a drama on several levels. One aspect is the book's adding color to the events of the chase by law enforcement officers from the Federal Bureau of Investigation, Pennsylvania State Police, and Chester County Detectives to identify, arrest and bring the offenders to justice. All the investigations and prosecutions in this case were federal and the case agent was FBI agent Dave Richter. We all worked well with — and would not have succeeded without — state troopers Tom Cloud, J. R. Campbell, Bob Martz, Paul Yoder and many others.

A second aspect is the parallel quest (we are using that term advisedly — it's not rhetoric) to secure the safe return of the stolen art. Among the 15 priceless artworks taken from the home of Andrew and Betsy Wyeth were Andy Wyeth's warm classic, *The*

Writing Chair, and his son Jamie Wyeth's powerful Rudolf Nureyev. The twists and turns of this quest brought many surprises; some of the players in this part of the case were not initially identified by the investigators.

A third aspect is the book's depiction of the characters of the ringleaders — Francis Matherly, Benny LaCorte and Bill Porter — and an examination of the roles of some of the approximately 23 others, in what we refer to as the "Matherly gang." For several years before the theft of the paintings, members of the Matherly gang participated in scores of residential burglaries in Chester County, Pennsylvania, and New Castle County, Delaware. After the cases were concluded, Chief County Detective Charles Zagorski told Dave Richter that the arrests and prosecutions in this case resulted in a reduction of a third of the residential burglaries in Chester County.

There is also a fourth level to this story that Jack Riley and I would refer to as the role of unintended consequences, as in other crime stories which are told in depth. Here, the three ring leaders never intended to get caught; nor did they intend to visit fear on countless homeowners and their children in these two counties, nor did they intend to set in motion a chain of events which led to a suicide and to a horrific murder.

Jack Riley and I believe that, ultimately, *Stealing Wyeth* is a story about how those who commit crimes — sometimes relatively small scale and sometimes drawing national attention, can be brought to bay by law enforcement officers who work best when they work together. These FBI agents, Pennsylvania state troopers, and Chester County detectives did their jobs not only with hard work, but also in the face of great danger. Although some might have assumed that professional burglar Porter was just that — a burglar who was crafty enough to disable burglar alarms — he was more insidious than that: he was a threat to the agents, state police and detectives who arrested him in that he had clandestinely concealed two pistols underneath layers of clothing.

Although Jack Riley and I are sure that Dave Richter, Tom Cloud, J. R. Campbell, Bob Martz, Paul Yoder and their colleagues would reject the term, and would say that they were just doing their jobs, to us they were and are heroes for being good men and women doing good jobs, in the fight against crime.

Walter S. "Terry" Batty, Jr.,
August 2018

Assistant U. S. Attorney Walter S. "Terry" Batty was the veteran prosecutor who handled the federal cases against the Wyeth art thieves. He was also the main federal prosecutor in the Johnston Gang cases.

Assistant U. S. Attorney John "Jack" Riley was part of the government team that gained convictions in the Wyeth art theft. Riley grew up in the area where the Wyeth art theft took place and his father was a Chester County judge.

ACKNOWLEDGEMENTS

The research for *Stealing Wyeth* has involved interviews with many people in the art world and law enforcement. I thank everyone who gave precious time to contribute to this book. I appreciate all the assistance I received in the telling of this story about one of America's greatest artists and the law enforcement community that recovered his priceless works of art and brought to justice the criminals responsible for committing the atrocious crime.

Former FBI agent David Richter and former Pennsylvania State Policeman Tom Cloud were two of the first people interviewed for this book. They were extremely valuable resources for the telling of the story. As with my Barricade book *Jailing the Johnston Gang: Bringing Serial Murders to Justice*, Dave and Tom deserve credit for faithfully retelling the part played by the law enforcement community.

Former assistant United States attorneys Walter S. "Terry" Batty, Jr., and John "Jack" Riley were interviewed for this book. Terry and Jack handled the criminal prosecutions in federal court. Also, they were kind enough to provide the foreword for the book.

Several members of the law enforcement community provided

information, including Pennsylvania State Policeman J. R. Campbell and FBI agent Carl Wallace. Attorney Robert Donatoni was interviewed for this book. Two former Chester County district attorneys, James Freeman and James P. MacElree, II, were also interviewed. MacElree later served as President Judge of the Court of Common Pleas of Chester County.

Members of the Wyeth family, including famed artist Jamie Wyeth, and those associated with the family provided assistance. Mary Landa, who is The Andrew and Betsy Wyeth Collection Manager, Dolly Bruni, Ann Call and Dawn Dowling all consented for interviews as did James H. Duff, former executive director of the Brandywine River Museum of Art. Chadds Ford artist Karl Kuerner, pupil of Andrew and Carolyn Wyeth, provided information. Billy Guthrie and George Malle gave me background on some of the incidents covered in this book.

One of my treasured professional relationship is with Barricade Books. Carole Stuart, former publisher, provided great assistance as this book developed during the past several years. Publisher Jonathan Bernstein recently has taken over the company and he has offered great support for *Stealing Wyeth*. I thank Carole, Jonathan, Carmela, and everyone at Barricade for their trust in my many book projects.

I've had many conversations over the years with my talented artist friends concerning aspects of this book, including Adrian Martinez, Karl Kuerner, Beth Palser Quindlen, Heather Davis, Candida Franklin and Donna Usher. They have all given me valuable insights and I thank them for taking the time to talk with me and share their knowledge. While I was drafting this book, Terri Smith was kind enough to review chapters and provide valuable feedback.

INTRODUCTION

I remember standing in the Newtown Square, Pennsylvania, office of the FBI as the public announcement was made that the stolen artworks of the great American artist Andrew Wyeth had been recovered. The one indelible image I have of the press conference is a beaming Betsy Wyeth, Andrew's wife, pointing out FBI agent David Richter and declaring he was the man responsible for solving the case. I was working for the *Daily Local News* of West Chester, Pennsylvania, at the time and our photographer, Bill Stoneback, captured the moment. The photograph was featured on the front page of the *Daily Local News* the next day. A framed copy of the page hung in Richter's office for many years.

For most members of the public, the story began with the theft of the paintings from the Granary on the estate of Andrew and Betsy Wyeth in Chadds Ford, Pennsylvania, in March 1982 and concluded with the press conference in January 1983 announcing the safe return of the artwork stolen from the most famous couple of the Brandywine Valley. For the public, little information was released during the 10 months the paintings were missing. The public silence belied the fact investigators were extremely busy tracking down leads on the whereabouts of the paintings. This

book details the actions of the law enforcement organizations in securing what many believe to be are priceless works of art and the capture of notorious and dangerous criminals.

The scant public news hid an investigative maze that took law enforcement officers from the banks of the gentle Brandywine River in Chadds Ford to members of two local criminal gangs known for their expertise in committing thefts. One gang thrived long after the leaders were incarcerated for multiple murders. The investigation led law enforcement to a professional cat burglar trained in defeating burglar alarms — his day job was installing burglar systems — to a chiropractor/barber/thief/teacher who masterminded the theft. Also involved in the investigation was a mushroom grower, assorted gamblers, Vinny "The Meat Man" Perry and other criminals and crimes, including murder and the theft of a valuable precious metal, platinum.

Where were the paintings during the months they were missing? A major concern was that the paintings had been spirited off to foreign lands. Savvy criminals would have had the paintings sold even before they were stolen. Maybe a wealthy collector had hung the paintings in a private room for only his viewing. Wyeth paintings, because of their value and popularity, had been targets of thieves even before the burglary at the Granary. Art theft is a lucrative criminal enterprise all over the world.

The core gang of criminals doesn't quite deserve the moniker "The Gang That Couldn't Shoot Straight," but they were far from the masterminds that pulled off the March 1990 theft of 13 works of art from the Isabella Stewart Gardner Museum in Boston. The Boston theft has never been solved. The Wyeth theft did have similarities to the Gardner heist and many other famous artwork thefts throughout history.

Criminals involved in the theft of the paintings were deadly dangerous. Many of the criminals involved in the planning and execution of the theft had links to the Johnston Gang. For more than a decade, members of the Johnston gang stole and robbed throughout Pennsylvania and many other states. The gang was

crippled in 1980 when three of the leaders, Bruce Johnston, Sr., David Johnston and Norman Johnston, were convicted of multiple counts of murder and sentenced to multiple life terms in prison. The victims were gang members, family members and a 15-year-old girl. They were killed to stop them from becoming witnesses against the gang members. William Porter, the professional thief who broke into the Wyeth property, was armed when he committed his crimes.

In early January 1983 I could sense a major development was about to take place in the case. I was covering the courthouse in West Chester, Pennsylvania. My usual sources were tight-lipped and the only way I could find out what was about to happen was to promise not to print anything until given approval to do so. I gave my word and was told the paintings had been recovered but the main criminal, Porter, had not yet been captured. He was dangerous, and the police didn't want Porter to know they were setting a trap to capture him. I remember walking out of the Chester County Detectives office and walking down a hallway and meeting noted defense attorney John Duffy, who defended one of those charged in the highly publicized ABSCAM case. Duffy asked me, "Did you hear, the Wyeth paintings have been recovered?"

If Duffy had given me the information about the paintings being safe before I made my pledge to Chief County Detective Charles Zagorskie of not authoring a story, I would have had a great exclusive. I had given my word and I didn't print anything until the FBI press conference. I also didn't tell my editors in fear they would have pressured me to do a story. I might have been able to justify the story based on Duffy's comment to me, but my explanation wouldn't have been believed and I would have been persona non grata in the courthouse for the rest of my career. I also remember a conversation I had with FBI agent Richter in the federal courthouse in Philadelphia while the hunt for Porter was taking place. I recall Richter being extremely concerned about the safety of individuals cooperating with law enforcement.

Stealing Wyeth is a true crime story about one of America's

most respected and talented painters, the criminals who were brazen enough to steal his paintings and the excellent work by law enforcement officials to recover the works of art and put the criminals behind bars.

Information for this book has come through many sources, including interviews, public documents, publications and notes from my reporting.

The Wyeth paintings have a special meaning for me. I've lived in the Brandywine Valley all my life and have grown up following the Wyeth family's artistic creations. The Brandywine River Museum of Art, home for much of the Wyeth family artwork, has been a refuge for me at times. I've visited the museum in Chadds Ford and looked at N. C. Wyeth's inspired book illustrations, Andrew Wyeth's timeless expressions of life in the Brandywine Valley and Jamie Wyeth's masterpieces. The artwork is an old friend and visits soothe my soul.

Bruce E. Mowday
Downingtown, Pennsylvania
August 2018

· 1 ·

STOLEN

A fortune in artwork created by world famous painter Andrew Wyeth was within the grasp of world-class professional burglar William Porter.

To gain possession of the prized paintings, all Porter had to accomplish was to traverse an open field carrying a 16-foot ladder without being seen; elude any family members, visitors or watchmen on the premises; climb to a second story window; enter the building and then disable an alarm system. He would, again without being detected, have to carry the pilfered paintings and ladder to a hiding place along a country road until a fellow thief could arrive and secure the paintings in a pickup truck and whisk him and the artwork from the scene of the crime.

The planned theft didn't appear to be easy pickings for Porter and his accomplices. Porter was recruited for the job by Chester County, Pennsylvania, criminals because he was a professional thief and an alarm expert. He admitted committing at least 1,500 burglaries in a myriad of states during his life of crime. Porter also possessed a sought-after skill for that night's work: he could dismantle burglar alarm systems. The Tennessee man's legitimate day job was installing those same alarm systems for customers. He did

have some scruples. He wouldn't rob a client, but he would sell systems to his victims after he committed crimes. Some of those new clients, Porter discovered, weren't quite honest themselves, as they would inflate the value of the items reported to their insurance companies.

The night before the theft Porter thoroughly scouted the Wyeth estate in Chadds Ford, Pennsylvania, along the banks of the Brandywine River. He was especially interested in the Granary, an outbuilding sometimes used as an art studio by Wyeth and an office by Betsy Wyeth, his wife. The criminals were sure that valuable paintings hung on the walls of the building. Another member of the criminal enterprise, Bennie LaCorte, had been inside the Granary and seen Wyeth paintings hanging on the walls of the building.

LaCorte, an associate of the notorious and murderous Johnston gang, had the bright idea of stealing a Wyeth painting after reading a newspaper report that one of the painter's renderings, *Marsh Hawk*, had sold for $468,000 at an auction in New York City. Original Wyeth paintings were in abundance in Chadds Ford, the winter home of the Wyeth family. LaCorte reasoned getting one of Wyeth's paintings would be a major haul for the local thieves.

Valuable intelligence was gained during Porter's visit the night before the theft. According to a melodramatic narrative Porter penned of the theft, when Porter was 30 feet from the Granary he saw a car enter the estate's driveway. The burglar had a decision to make. He could retreat and run back through the meadow to the road or he could dash to the Granary and risk being seen and setting off an alarm. Porter bolted to the building and arrived without being detected. He watched someone from the house with a dog approach the car. The person had a conversation with the occupant of the vehicle. The car was eventually parked at the far end of the driveway, a distance from the Granary, and the two people disappeared from sight. Porter estimated the time at a few minutes after 9:00 p.m. on Friday, March 26, 1982. Porter believed the man arriving at the Wyeth home was a watchman.

He was determined to complete the burglary the next night by 9:00 p.m., thus avoiding the watchman making his rounds. During this pre-burglary visit, Porter also determined he needed a ladder to reach the second-floor window.

Another accomplice, Francis "Franny" Matherly, earned his criminal reputation by being a fence of stolen property. Franny could be counted upon to find buyers for pilfered goods, especially expensive items. He dealt in all types of stolen goods, including cars, jewelry, weapons and antiques. Franny was Porter's getaway driver the night of the Wyeth theft.

As night fell, Franny and Porter climbed into Franny's truck and drove along Creek Road, also known as Pennsylvania Route 100, until the criminal pair was approximately 500 feet south of the Wyeth family's driveway. On the west side of the road, where the Wyeth estate was located, was a steep embankment and a large tree. The pair of thieves designated the tree and embankment as the spot for Porter to hide stolen paintings until Franny could secure them in the back of his pickup truck. Franny realized the location wasn't an ideal place to retrieve the paintings as nearby there was a curve in the road with a rise. Franny would have to be careful. He didn't want to be spotted. Also, he didn't want to cause a traffic accident.

After dropping off Porter, the ladder and burglary tools, Franny retreated to the Chadds Ford Inn, a short distance away at intersection of routes 1 and 100, to await a call on a walkie-talkie from Porter. If the burglary went amiss, Porter was to make his way to the inn to rendezvous with Franny and the pair would make their getaway. Franny had a drink at the bar before returning to his truck. He would wait approximately 90 minutes before receiving Porter's summons.

Carrying a ladder across a field and making several runs from the Granary to the road while carrying paintings is a physically draining exercise for most people. Porter was easily up to the task. Porter kept in fit shape. He later told police a professional burglar had to do so to avoid being captured in case a chase ensued.

A passing car on Creek Road delayed Porter's initial advance to the Granary. He waited in the meadow but used the few moments to scout the Wyeth residence. The burglar noted a light was shining in the home and several vehicles were in the driveway. He couldn't see anyone walking the grounds. He also heard the Brandywine River running behind the Wyeth's home. Porter made a mental note that if he needed a quick escape route, he could use the river even though it meant a wet and cold getaway experience.

After the car was out of sight, Porter carefully and silently made his way across the meadow. He vigilantly watched for dogs as he didn't want a canine to noisily announce his arrival. As Porter approached within 200 feet of the Granary, he slowed to a walk. He saw vehicles parked in an open garage and others in the driveway. Porter was surprised that the area didn't have better lighting to deter less determined burglars. He also couldn't detect antitheft sound or camera systems.

On the side of the Granary that couldn't be seen from the house, Porter planted the ladder. The professional burglar slung his burglary tools on his shoulder and climbed the ladder to the second floor. In his sack were white sheets and pillow cases to wrap around picture frames. He fancied himself a great Santa Claus climbing on the ladder with his sack. Ho. Ho. Ho. Saint Porter was bent on filling his sack with presents for himself, not leaving gifts for good little boys and girls.

Inside the second floor Porter could see paintings, antiques, a bed and a patchwork quilt. What Porter didn't see on the second floor was evidence of an alarm system. He knew the first floor had been wired for an alarm. A digital keypad was on the wall. He guessed because of the placement of the keypad, which was away from the solid wooden doors, that a lengthy interval would take place between the alarm being tripped and a siren being triggered. The alarm system being utilized by the Wyeth estate, in Porter's expert opinion, was not sophisticated and could easily be circumvented.

Upon entering the second floor, Porter double-checked for

alarms. He wanted to make sure a stress alarm had not been imbedded in the floor. As he made his way towards the alarm system on the first floor, he knew he would have more than enough time to disable the keypad since a motion detector wasn't installed.

Porter was in for a pleasant surprise when he reached the keypad: the alarm wasn't activated. He wouldn't have to call upon his professional expertise to quickly silence the system. There was also enough lighting in the room to maneuver without using his small flashlight, thus decreasing the chances he would be discovered.

The burglar's first task upon leaving the building was to take down the ladder from the side of the building and hide it in the meadow. He then carried three of the paintings across the meadow and propped them at the base of the tree near Creek Road. Porter radioed Matherly that paintings were ready to be recovered. In a few minutes the paintings were in the pickup truck. The three-painting haul was plenty for Franny. The fence was ready to end the night's work and call the operation a success.

Not so quick.

Porter was not about to leave multiple expensive paintings hanging on the walls of the unsecured Granary. Franny departed the area and headed back to the Chadds Ford Inn as Porter returned to resume the burglary. Porter didn't have enough sheets to cover the paintings he selected, so he stripped the bed and took an expensive quilt to cover the works of art.

Porter first carried the paintings out of the Granary and then transported them to the designated recovery location, the tree, and placed the paintings side by side so a passing car couldn't spot them. Several times Porter flattened himself in the meadow as cars passed on Creek Road. Finally, Porter was ready for Franny and radioed his accomplice. Porter later wrote he told Franny that his "equipment is packed and ready at Tree Street."

Franny helped to load 15 paintings. Most were by Andrew Wyeth, but three other artists' works were part of the criminals' haul. Franny was anxious to depart the area, but Porter again ran back to the meadow to retrieve the ladder he had purchased earlier

in the day at an 84 Lumber store. Porter wanted to make sure the ladder couldn't be traced to him.

A fortune in paintings was bouncing along in the back of the burglars' pickup truck as they drove away into the night.

* * *

As Porter and Franny were looting the Granary, Andrew and Betsy Wyeth were enjoying a rare night out with friends. Dolly Bruni invited the Wyeths to a dinner party at her nearby Marshall-ton home. The Wyeths rarely ventured out at night as Andrew especially liked his solitude. One of the places the Wyeths did frequent was the Chadds Ford Inn, the same inn Franny utilized as a base while waiting for Porter's message that the paintings were ready to be transported.

Bruni recalled having eight people at the dinner party that Saturday night, including local artist Dennis Haggerty. All of Bruni's dinner guests were thoroughly questioned by law enforcement. Had one of them alerted the burglars that the Wyeths wouldn't be home that evening? A relieved Bruni remembers a conversation with an FBI agent when she was told she was cleared and no longer considered a suspect.

Upon their return from the dinner party, the Wyeths didn't notice anything unusual or out of place. The couple retired for the evening.

The following morning the Wyeths had a visitor, Ann Call, a model residing in Strasburg, Pennsylvania. Previously she spent a year living at the Granary in the small second-floor space. The vast majority of the paintings and furnishings at the Granary were housed on the second floor because the Brandywine River flooded at times and water seeped into the bottom floor. Betsy's office was on the second floor. The first floor contained a small kitchen, mostly utilized to make coffee.

Call paid frequent weekend visits to the Wyeths and usually arrived on a Saturday. FBI agent David Richter told her on the

weekend of the theft she was lucky to have waited until Sunday because she might not have survived the Saturday night burglary.

Betsy and Call went to brunch before visiting the Granary to work on a knitting project. They didn't do a stitch. The two women could tell something was amiss as they approached the building. "The heavy bolted door was open," Call recalled. "I never saw that door left open." The women went inside and headed to the second floor.

After discovering the disturbing looting of the cherished paintings, Call managed to maneuver the distraught Betsy to a chair on the second floor and have her sit down. "It was so upsetting. We were in shock," Call said. The stolen paintings were owned by Betsy, given to her as gifts. Call alerted the local Birmingham Township police department and poured herself a half glass of vodka. "Betsy looked frightful and we were speechless. One of the inside doors was pried open. I thought Betsy was going to have a heart attack, she looked so frightened."

A theft taking place at the Wyeth estate was not a total surprise. Upon arrival, Call said one of the township policemen uttered, "I'd been waiting for this call for a long time." Call also was not shocked. "Jesus Christ, someone finally did it," was her comment to a friend that day.

Betsy and Call departed the Granary and went to the main house to await Andrew's arrival. "Betsy was afraid Andy would be upset when he returned home and saw all of the police cars," Call said. While waiting for Andrew and reports from the police, Betsy had Call alert several friends, including the hostess of the dinner party, Bruni, and close family friend George Weymouth, better known to his friends and members of the art and equine community as Frolic.

Weymouth, a member of the du Pont family, had been married to Andrew's niece and Andrew's son Jamie married Weymouth's cousin. He resided in an 18th-century house on a 250-acre estate called the Big Bend in Chadds Ford, near the Wyeth's home. Weymouth was known as Andrew's confident. In a documentary

Wyeth said he didn't "know of anyone who means as much to me."

Andrew and Weymouth also shared their love of painting. Weymouth was a painter of some renown. His portraits included those of Luciano Pavarotti, the great Italian operatic tenor, and Prince Philip, Duke of Edinburgh, of Great Britain. Weymouth was one of the founders of the Brandywine River Museum of Art, a museum that features the work of the Wyeth family. Weymouth's paintings are also displayed at the museum.

When Andrew returned home that Sunday afternoon he looked around and inquired about what had taken place. The police were busy attempting to find out themselves. A new crowbar was found in the Granary. Porter always used newly purchased burglary implements. He never used tools from his home as he didn't want the burglary tools connected to him. The crowbar was utilized to pry open a closed door to a closet holding paintings waiting to be shipped. The crowbar was found near an empty space that the day before had featured a John Crawford painting.

The police correctly surmised the burglar gained entrance by placing a ladder up to the second-floor bedroom window. As the police continued their investigation, Betsy recalled an incident the night of the burglary. Gnome, her white Chinook dog, shot out of the house and ran towards the Granary. Betsy said she had a difficult time calling Gnome back to the house.

One of the first tasks for the Wyeths was to determine what pieces of art were missing. A call was made to Mary Landa, The Andrew and Betsy Wyeth Collection Manager. When Landa arrived, she found the messy condition of the Granary shocking. "Everything in Betsy's life was so orderly," Landa said. "When I walked in I asked, 'Where is the John Crawford?' The wall was blank where it previously hung. Betsy was so rattled. She asked me to tell her what was in the closet before the burglar broke in with the crowbar. The closed door being open was a horrific sight."

The paintings taken were from Betsy's private collection. If Porter and his associates had robbed the main house, they would

have found more valuable paintings. Porter passed up 16 other paintings in the Granary, including a very valuable oil painting by N. C. Wyeth, *Polar Bear*. N. C. was Andrew's father and a famous painter and book illustrator. The quilt Porter used to cover the painting was actually an 18th-century coverlet. The piece was hand-woven linen and cotton with a quilting design on one side. The estimated value of the coverlet at the time was $2,000. The item was never recovered.

Landa kept detailed records of the Wyeth paintings and those stored at the Granary. She determined the stolen paintings included seven paintings by Andrew, six by Andrew's son Jamie and one each by artists John Crawford and Henry Casselli. They were:

Writing Chair by Andrew Wyeth
Thawing by Andrew Wyeth
Saracen Helmet by Andrew Wyeth
Block and Tackle by Andrew Wyeth
Charlie Stone's Fish House by Andrew Wyeth
Gray Mare by Andrew Wyeth
Baron Phillippe by Andrew Wyeth
Shorty by Jamie Wyeth
Whitewash by Jamie Wyeth
Two pencil sketches of Rudolph Nureyev by Jamie Wyeth
Portrait of Andy Warhol by Jamie Wyeth
Moon and Horse lithograph by Jamie Wyeth
North Sea by John Crawford
After Rehearsal by Henry Casselli

The burglary upset Betsy for the next two years, friends said. She obsessed and distressed about the theft and even became distrustful of close friends. "That is what happens with such a personal violation," one friend said. Betsy told one newspaper reporter, "It was a sinking feeling (when the paintings were discovered missing). The door was open, and I couldn't believe I left it open. It was an intrusion, an intrusion into our privacy.

They were all gone. I didn't like those blank spaces on the wall." Andrew was characterized as being more worried about Betsy than the loss of his paintings. He remarked that he could always paint new ones.

The theft on the evening of Saturday, March 27, 1982, amounted to a hard lesson learned by the Wyeth family. The alarm system had to be activated for it to protect the property. An explanation was given that the alarm malfunctioned. In fact, the alarm was hardly ever turned on. Andrew had a habit of setting off the alarm every time he entered the building, which annoyed Betsy. So, the solution was not to activate the alarm.

Immediately, a guard was hired to sit at the end of the driveway entrance to the Wyeth estate. Also, trip lighting was installed so any vehicle entering the property would be bathed in light. Additional security improvements were added to protect the property, the Wyeth family and the priceless, irreplaceable paintings.

· 2 ·

ANDREW WYETH

The Chadds Ford thieves weren't aware they had keen artistic eyes, but they did. Burglar William Porter admitted he hadn't heard of world famous Andrew Wyeth before being invited to take part in the Granary heist. Andrew, the artist unknown to the burglar, earned his reputation as one of the greatest American painters of all time and certainly one of the best-known artists of the 20th century.

Andrew was a proud descendant of the Brandywine School of Art. N. C., Andrew's father, was a pupil of Delaware painter Howard Pyle, who established the Brandywine artistic brand and is known as the father of American illustration. Pyle's illustrations were widely published in adventure and romance books and magazines during the late 18th century and early 19th century.

Pyle was also a teacher and conducted art classes at Drexel University in Philadelphia, beginning in 1895. Pyle's tenure as a teacher of formal art education lasted only five years as Pyle was not happy with the parameters of formal art education imposed by the school. To explore teaching his own brand of art, Pyle began summer instruction of students at Turner's Mill in Chadds Ford. The mill was situated along the picturesque

Brandywine River, a scenic venue that continues to inspire artists to this day.

In 1900 Pyle established his own school and studio in Wilmington, Delaware, and formally cut ties with Drexel. Pyle's goal was to train a generation of artists and illustrators who would not only be successful but establish an American style of painting that Pyle believed was lacking in the country.

Pyle molded American-trained artists steeped in American history and appreciative of the beauty of America's landscapes. Pyle took his students on field trips and one of his favorite outings was to Chadds Ford. The teacher was known for telling stories of the great American Revolutionary battle fought along the banks of the Brandywine River while his students painted.

The new art school was very popular, as 500 students applied for admission the first year. Pyle accepted only 12 of them. In the decade the school operated under Pyle's direction, Pyle trained 75 students. Graduates became some of the best known artists of their time, including Frank E. Schoonover, William James Aylward, Anna Whelan Betts, Ethel Franklin Betts, Ellen Bernard Thompson Pyle, Jessie Willcox Smith, Harvey Dunn and, of course, N. C. Wyeth.

Newell Convers Wyeth was known as a force within the art world, his community and his family. He continued to paint in Wilmington for several years before moving to Chadds Ford. In his storied career, N. C. is credited with completing 3,000 paintings and created illustrations for 112 books, many of them for the famed book publishing firm Scribner's. Just one his paintings for an illustration for a Scribner book was listed at auction in January 2018 at an estimated value of $250,000.

The Wyeth family is an American family. N. C. was born in Needham, Massachusetts, in 1882. The Wyeth family's roots in that Commonwealth date to 1645. Members of the Wyeth family took part in conflicts that established American freedom and defined the country as it is today. Family stories from those who

participated in the French and Indian Wars, the American Revolution, the War of 1812 and the Civil War provided material for the Wyeth family of painters.

The first commission for N. C. came from *The Saturday Evening Post* in 1903. The result was a cover illustration of a bucking bronco and a cowboy. N. C. was quoted as describing his work as "true, solid American subjects — nothing foreign about them."

N. C.'s first artistic schooling was in Massachusetts. He attended the Massachusetts Normal Art School in Boston. After one of his friends, Clifford Ashley, returned to Boston touting the training he was receiving in Pyle's school, N. C. applied. He was accepted and connected to the art style being taught by Pyle. Pyle urged his pupils to experience life. N. C. wanted rigor and ecstasy in his training and life, according to the biography *N. C. Wyeth* by David Michaelis. Of N. C.'s Boston training, Michaelis wrote, "In drab classrooms, he listened as lecturers tried to 'arouse in the minds of the despairing pupils an interest in combined angles, shadow planes, vanishing points, foreshortened circles, roofing timbers, and other hopeless mysteries.'"

Pyle urged N. C. to go forth and experience life. N. C. followed Pyle's advice and traveled to the American west. N. C. spent time with cowboys working on a ranch in Colorado and visiting the Navajo in Arizona. Later the painter said the West seemed to beckon him as his real home.

N. C. met Carolyn Bockius of Wilmington at a sleighing party in January 1904 and they married in April 1906. The couple moved to Chadds Ford two years later and had five children, Andrew, Henriette, Carolyn, Ann and Nathaniel. Andrew was born on July 12, 1917. All three daughters were painters and Ann was also a composer. Nathaniel worked as an engineer for the DuPont Company. Henriette married Peter Hurd and Ann married John McCoy. Hurd and McCoy, both artists, trained under N. C.

John McCoy

Peter Hurd

Over the years the family had a number of famous visitors, including F. Scott and Zelda Fitzgerald and Lillian Gish. One story circulated that after one visit Fitzgerald deemed their car dirty from the dusty roads of Chadds Ford and drove it into the Brandywine River.

The Wyeth family is associated with Maine as well as Chadds Ford. The Wyeths historically spent the winters in Chadds Ford and summers in Maine. N. C. restored an old sea captain's home in Port Clyde, Maine, in the 1930s. The home was named after a painting by another American master, Winslow Homer. N. C.'s career prospered and began exhibiting in national shows while museums purchased his paintings.

Tragedy struck the Wyeth family and the art world on Friday, October 19, 1945, when a freight train struck a car at a railway crossing on Ring Road near Chadds Ford at about 9:15 a.m. The Octoraro branch of the Pennsylvania Railroad intersected Ring Road at a grade crossing one mile from the village of Chadds Ford, less than a mile from N. C.'s home and near the home of his friends, the Kuerners. In the car were N. C. and his grandson Newell. N. C. spent many mornings with his grandson and that morning he picked up his grandson from daughter-in-law Caroline Wyeth to do an errand. They both died. Young Newell was a

month shy of his fourth birthday and N. C. was three days shy of his 63rd birthday.

His father's death had a great impact on Andrew in personal and professional areas of his life. Andrew returned to the site of his father's death many times. For a time, Andrew painted through the lens of his father, according to Michaelis. Michaelis quoted Andrew as saying, "His death was the thing that really brought me to life. It gave me a reason to paint, an emotional reason. I think it made me."

Patricia Junker wrote in the book *Andrew Wyeth In Retrospect* that Andrew said of N. C.'s death, "My father's death … put me in touch with something beyond me, things to think and feel, things that meant everything to me. Then I needed to put them down as sharply as possible—with the clarity of the north wind."

Michaelis summed up the relationship between Andrew and his father by writing, "Year after year, as the list of Andrew Wyeth's honors and prizes lengthened, as the sale of his temperas brought in millions, Andrew became increasingly driven to preserve the legacy and the artist who had made it possible for him to paint. N.C.'s unselfishness as a father, his chronic self-devaluation as a painter, haunted Andrew for the rest of his life."

Andrew spent many hours as a youth in his father's Chadds Ford studio. Michaelis wrote in his book on N. C., "In the store-room off the vestibule, Andrew examined stacks of his father's past canvases, learning from the illustrations. He loved N. C. Wyeth's pictures and felt that through them he knew his father in a different way than his sisters and brother did. Alone among the children, Andrew studied the work, returning to it day after day, year after year as he grew up.

"He never attended school. Mornings he was tutored by Chadds Ford neighbors. Still too young for formal training under his father, Andrew continued to draw. First it was English grenadiers and pirates that filled his drawing pad, then crusaders in armor. In 1925, when Andrew was eight, N. C. took the children to see King Vidor's new silent movie, *The Big Parade*. Andrew

would long remember his father's 'vibrant enthusiasm when he told about it.' Starkly realistic, *The Big Parade* was a war movie that really looked like war, and Andrew would never lose his first ecstatic feeling about it."

Two of the local neighbors, Edith and Lydia Betts, tutoring young Andrew had connections to the local Chadds Ford school.

Andrew, at age 15, officially became his father's pupil in October 1932. Wrote Michaelis, "Andy entered the studio on Rocky Hill to begin his apprenticeship. He would have as his teacher a father who meant for his son to be the better craftsman. 'If you're not better than I am,' N. C. would tell Andy, 'I'm a rotten teacher.' He was the only teacher Andy Wyeth would ever have."

Andrew's first experiences with a New York gallery was when he was just 19. At the urging of his father, Andrew took 20 watercolors and two black-and-white drawings to the Macbeth Gallery at 11 East 57th Street on January 4, 1937. Andrew had not made an appointment and went unannounced. The gallery's president, Robert Macbeth, wrote that Andrew had something new to offer the public and that he wanted to help Andrew make his New York debut. The gallery hosted Andrew's first show, which opened on October 19, 1937.

In 1938 Andrew had a show at the Currier Gallery of Art in Manchester, New Hampshire, that so impressed N. C. that the father wrote to his daughter Henriette, "The bulwark of my stay here this summer will be Andy's accomplishments. His watercolors have so definitely advanced into impressive maturity … their impact on any one whose sensitiveness is beyond romance and dreams makes it hard to hold back tears."

Preparing for his second show at the Macbeth Gallery, Andrew was earnestly painting in Maine. On July 11, 1939, N. C. greeted a visitor in the family's Maine residence, Merle Davis James, an editor of the Buffalo *Courier Express* and amateur painter. A friend suggested that James look up N. C. since they were both spending the summer in the same part of Maine.

Andrew needed a break from his painting, took a day off and

searched for the home of the James family. He found the property with a sign M. D. James. Andrew thought James must be a medical doctor when he rang the bell and was greeted by Betsy James, one of James's three daughters. Betsy was a student at Colby Junior College in New Hampshire and when Andrew was asked what he did, he said he was a medical student at the University of Pennsylvania, hoping to impress Betsy.

Betsy was informed Andrew was a painter and later took him to see some of the seacoast vistas of her youth. One of the places was the home of Christina Olson, who suffered from polio. Later Christina became famous in Andrew's painting *Christina's World*, which was acquired by the Museum of Modern Art in New York City.

Betsy James married Andrew on May 15, 1940, in East Aurora, New York. They had two sons. Nicholas was born in 1943 and James, known as Jamie, three years later.

Andrew's second show at the Macbeth Gallery was as successful as the first. Almost all of his work was sold before the show opened. In December of the same year N. C. was featured in a show at Macbeth's gallery. New York newspapers called N. C. "Pa" of the "Clan Wyeth" as Andrew and other members of the Wyeth family were gaining artistic fame throughout the country.

During World War II interest in the art world dipped and artists' incomes were diminished. Andrew turned down an offer to join the U. S. Navy's Combat Artists Corps. He didn't want to paint the images of war. His health, a bad hip and a weak lung, kept Andrew from military service but he still contributed to his county's war efforts by producing a poster encouraging wartime productivity.

Andrew painted scenes of Chadds Ford and Maine. In succinctly summing up his subjects, he once aptly said, "I paint my life." Andrew's style has been described as a visual artist, primarily a realist, akin to Winslow Homer or Thomas Eakins. Andrew himself believed he was an abstractionist. In a 1965 *Life* magazine article, Andrew said, "My people, my objects breathe in a different

way: there's another core—an excitement that's definitely abstract. My God, when you really begin to peer into something, a simple object, and realize the profound meaning of that thing—if you have an emotion about it, there's no end."

On the national scene, Andrew became a star. When Winston Churchill visited Boston in 1949, Churchill requested Wyeth watercolors be hung in his room at the Ritz-Carlton Hotel. In 1950 at age 33, Andrew was elected a member of the National Institute of Arts and Letters. Five years later he became the youngest member of the American Academy of Arts and Letters.

Stars were also seeking out Andrew. In 1985 singer Michael Jackson approached Andrew about doing a portrait. The two met at the Brandywine River Museum of Art and Andrew reported having liked Jackson and thought about doing a painting. The project died when Andrew saw Jackson's handlers controlled Jackson's life. Richard Meryman in his book *Andrew Wyeth: A Secret Life*, wrote of Andrew's impressions, "The poor guy (Jackson) is owned by these people (the handlers). I felt sorry for (Jackson). God help any artist that gets caught up in that. Imagine me painting with those guards standing there. The whole thing was the maddest idea I ever heard. Just nuts. I was fascinated. There was a connection. I could have done something interesting."

Personally, Andrew didn't like the attention he was gaining and retreated from the public. Andrew's sister Ann commented in Meryman's book that fame was "hell on Andy. People were after him. Calling him on the telephone. They were always sucking up to him. People bought pictures without seeing them first. Just an investment. That hurt."

Andrew was portrayed as a secretive man who spent hours tramping around the countryside alone. He disliked having someone else watching him paint. Artist Karl Kuerner, grandson of the Karl Kuerner painted by Andrew in numerous works, was the only non-Wyeth family painter instructed by both Andrew and Carolyn Wyeth. Kuerner once stealthy sketched Andrew while the great artist was working. Andrew visited Kuerner's home to sketch

a deer head mounted on a wall. As Andrew worked, Kuerner went to his second-floor studio, grabbed a note pad and water colors and quietly sketched Andrew.

"A few hours went by without Andy seeing what I was doing," Kuerner said. "When Andy completed his sketch of the deer head, he offered to show it do me. 'What do you think?' Andy asked. I responded, 'Andy, I really don't care. What do you think?' I then showed Andy my watercolor of him at work. Surprised and laughing, Andy said, 'You got me.' I think of the opportunity I might have missed if I hadn't taken the chance to sketch him. I was in Andy's world of creating at that moment and I'm glad I captured him."

One of Andrew's most celebrated series of paintings was of Helga Testorf, who was attending the Wyeth family's friend Karl Kuerner, the painter's grandfather, when he was in ill health. For more than a decade Andrew made hundreds of studies of Testorf. The works were exhibited in the National Gallery of Art in 1987 and made a nationwide tour. The collection was first sold to a Philadelphia collector for an estimated $6 million and then to a Japanese industrialist for an estimated $40 million.

Shows of Andrew's work at museums have garnered large audiences. His paintings have also been featured at the White House. In 1967 a retrospective exhibition was organized in Philadelphia and was well attended at stops in Baltimore, New York and Chicago. A Wyeth retrospective at the Philadelphia Museum of Art in 2006 drew more than 175,000 visitors in 15½ weeks, the highest-ever attendance at the museum for a living artist. For three decades Andrew was featured at the Whitney Museum of American Art in New York City.

Andrew's work is included in many of the nation's leading museums, including the Museum of Modern Art, the National Gallery of Art, Metropolitan Museum of Art, the Cincinnati Art Museum, the Smithsonian American Art Museum, the Nelson-Atkins Museum of Art, the Brandywine River Museum of Art, Farnsworth Art Museum, the Greenville County Museum of Art and the Arkansas Art Center. International museums include the National Museum

of Modern Art in Tokyo; the Hermitage Museum in St. Petersburg, Russia; the Palazzo Reale in Milan, Italy; the Fukushima Prefectural Museum of Art in Fukushima, Japan; the Marunuma Art Park in Asaka, Japan, and the Academie des Beaux Arts, Paris.

Andrew received a number of prestigious honors, including the National Medal of Arts, the Congressional Gold Medal, the gold medal for painting from the National Institute of Arts and Letters and the Presidential Medal of Freedom. He was also the first living American artist to be elected to Britain's Royal Academy and the first American artist since John Singer Sargent to be elected to the French Academie des Beaux-Arts.

As N. C. was a teacher to son Andrew, so was father Andrew to his son Jamie. Like Andrew, Jamie spent time in his father's studio. Also, like Andrew, Jamie was taught at home rather than in a formal school. Jamie spent two years of academic training with his aunt Carolyn along with instruction by Andrew. Jamie called Andrew a great teacher.

Jamie earned his own accolades as a young painter. He was invited to Hollywood to do sketches for a movie promotional campaign and then asked by Jackie Kennedy to do a posthumous portrait of President John F. Kennedy.

On being a third generation Wyeth artist, Jamie told Meryman, "I had the ghost of N. C. Wyeth, who was the magical being, the painter who produced those illustrations and had left behind all the trappings to produce everything. His knights in armor excited me much more than what my father was working on. But my father was working constantly, from the minute the sun came up … a role model for total absorption—the belief that painting is a serious business. Those two pulls worked. Somehow in between I could survive."

Andrew died in his sleep at his Chadds Ford home on Friday, January 16, 2009. He was 91 years old. The *Associated Press* said Andrew "portrayed the hidden melancholy of the people and landscapes of Pennsylvania's Brandywine Valley and costal Maine." The *Los Angeles Times* reported, "Andrew Wyeth, whose

realistic yet often melancholy paintings of rural Pennsylvania and Maine made him one of America's most popular living artists, and whose 1948 landscape 'Christina's World' was one of the 20th century's most famous artworks, died Friday."

James Duff, then director of the Brandywine River Museum of Art, said, "He was a man of extraordinary perception, and that perception was found in his thousands of images — many, many of them iconic. He highly valued the natural world, the historical objects of this world as they exist in the present and strong-willed people."

Andrew, according to the *Los Angeles Times* obituary was called a "'master of the magic-realist technique' and lauded as one of the greatest American artists. *Life* magazine declared him 'America's preeminent artist' in 1965."

Yes, the Chadds Ford thieves had keen artistic eyes.

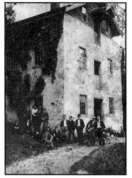

Howard Pyle and students at the mill studio, Chadds Ford, 1902.

Turner's Mill, Chadds Ford, PA

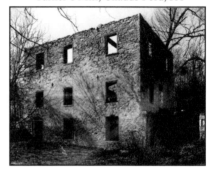

The mill was later converted to a residence but burned in the 1950's. Turners Mill also known as Howard Pyle's studio was purchased by the Chadds Ford Township in 1976. The grist mill had fallen into disuse by the 1890's when Howard Pyle rented it as an art studio for his summer strudents (including N.C.Wyeth). The township converted the building to a township hall around 2005 under the guidance of architect John Milner.

Turner's Mill 2018

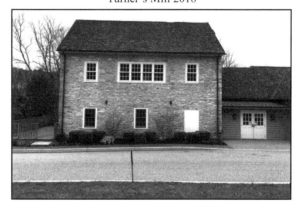

· 3 ·

IDENTIFYING CULPRITS

The resources and capabilities of the local township police force to investigate the theft of the Wyeth paintings were lacking. By the time the crime was discovered, little chance existed that the 15 works of art remained within the less than seven-square-mile jurisdiction of the Birmingham police force.

Responsibility of finding and recovering the stolen paintings and identifying the culprits responsible for the millions of dollars in lost art was turned over to the Pennsylvania State Police. The initial trooper assigned to the case was soon replaced by state policemen Thomas Cloud, J. R. Campbell and Robert Martz. Cloud had an intimate knowledge of Chadds Ford and the Wyeths. Cloud grew up in the area, his grandmother was one of Andrew's tutors and Cloud personally knew the Wyeth family.

State policemen in Avondale were no strangers to crime. At the time, the Avondale barracks was the second busiest state police station in Pennsylvania.

The FBI was not immediately notified of the theft as no federal laws were known to have been breached at the time. FBI agent David Richter read about the Wyeth burglary in a local newspaper the day after the crime took place and immediately drove from his

suburban Philadelphia office in Newtown Square, Pennsylvania, to the Avondale barracks in southern Chester County to meet with Cloud. Richter had a strong relationship with those same state policemen as they had recently jointly investigated the murderous Johnston gang.

Cloud's first suggestion was to talk to a local character named Jimmy Lynch. Lynch was a member of a small group of Chester County people that were in the Andrew Wyeth's sphere of acquaintances. Lynch grew up near where the Wyeth family lived and was a boyhood friend of Jamie Wyeth. Jamie said Lynch was like a brother to him. Andrew used Jimmy as a model in several of his paintings. Lynch, himself, became an artist.

One newspaper story called Lynch "an appealing vagabond," when he died in 2008. Another newspaper reported, "For those who grew up in Chadds Ford in the 1960s, 1970s and 1980s, Jimmy Lynch was as recognizable as the Wyeths, but more infamous than famous. Lynch was perhaps best known for living life on the edge and as the subject of Jamie's painting *Draft Age*."

Richter said, "Lynch was a colorful fellow who knew everybody. He was a piece of work himself."

The investigators paid Lynch a visit at his little home in Chadds Ford. Lynch was asked what he knew about the Wyeth theft and Lynch professed his knowledge was nil. During the interview Lynch did mention that another local character, Benny LaCorte, had recently asked him questions about the Wyeth paintings.

"We went to Jimmy that first day of the investigation," Richter said, "and boom we were put on to the right track. It is one thing to be on to the correct path but a totally different thing to be able to prove what took place. We had a lot of work ahead of us. Jimmy wasn't surprised we visited him that day; he downplayed the whole theft. Lynch was a cool customer and a character. Jimmy didn't get flustered by anything."

Cloud had known Lynch since Lynch was a little child. "He had a rough upbringing, but he was OK." Richter also indicated Lynch was basically a good person. "I will also say, Jimmy was

involved in drugs and other activities and he knew his way around (the criminal world of Chadds Ford). Jimmy once called us about a guy wanted for murder. We tried to find the murder suspect but couldn't do so. Jimmy finally talked to a trooper in Delaware who did some work and the suspect was arrested. Jimmy did the right thing in the murder case and was cooperative. Lynch wasn't a bad guy."

Lynch and members of his circle mingled with Andrew. "Andy found them interesting, the bad guys," Richter said. Cloud added, "Andy had time on his hands and hung around with Jimmy in Chadds Ford. As far back as school Jimmy was in with the Wyeths. Jimmy had an unlikely connection with the Wyeths in many ways."

Lynch's interview with Richter and Cloud certainly did put the investigators on the right track. "As soon as we heard Benny's name we had a starting point and were pointed in the right direction," Cloud said. "We knew the players." LaCorte was a crook who had a number of dealings with law enforcement.

Cloud and Richter were well acquainted with LaCorte's old band of thieves, the Johnston gang. The two law enforcement officials had just spent four years working on multiple interstate thefts, burglary and murder cases involving Johnston brothers Bruce, David and Norman and their criminal associates.

The Johnston gang terrorized Chester County and committed crimes up and down the east coast. The criminals' specialty was stealing heavy construction equipment and John Deere tractors. There were more John Deere tractors stolen in the Pennsylvania, Delaware and Maryland area where the Johnstons operated than the rest of the country combined. They would steal individual tractors from farmers' fields and truckloads of the vehicles from John Deere dealers. The gang took a liking to Corvettes. More than 200 of the sporty cars were pilfered, cut up into parts and sold by the Johnstons. After the Johnston brothers were imprisoned, the number of thefts of heavy equipment dramatically dropped.

The gang operated for more than a decade and didn't limit their quest to cars, tractors and heavy construction equipment. The Johnstons also dabbled in drugs and antiques. And, they would steal to order. A client could ask for a particular item for a car or home and the Johnstons would quickly have it for them at a reduced price. As law enforcement officials said, the gang would steal anything not tied down and even secured items fell prey to the Johnstons. James Duff, the executive director of the Brandywine River Museum of Art, recalled the Johnstons stealing maintenance equipment from the museum.

A network of fences aided the Johnstons in selling stolen property and there were always willing buyers for the pilfered items. Businessmen and a school teacher were sent to federal prisons for making a buck off the Johnstons' stolen merchandise. Gang members were known by police and Johnston associates did spend some time in jail. Astute defense attorneys and a well-earned reputation for intimidation and retribution against witnesses helped the Johnstons escape lengthy periods of incarceration. That is, the Johnstons escaped long periods of incarcerations until they turned to murder.

Cloud said, "These guys' sole aim was staying on the street. They would pay lawyers, intimidate witnesses, and even pay off witnesses. They spent their waking moments working on staying on the streets."

In 1977 Gary Wayne Crouch, one of the Johnstons' gang members and police informant, disappeared without a trace after reluctantly joining Johnston, Sr. and gang member Leslie Dale to commit a burglary. The next year, in August 1978, three young associates of the Johnstons, members of the Kiddie Gang wing of the Johnstons, disappeared after getting subpoenas to testify before a federal grand jury in connection with the thefts committed by the Johnston gang. Another gang member, and brother of one of missing Kiddie Gang members, then went missing after he questioned the Johnston brothers about the whereabouts and wellbeing of his brother.

Five members of the Johnston gang were missing. Family members and law enforcement were concerned about the safety of the missing men, but at that point the Johnston brothers weren't linked to murder. Two of the Johnston brothers, Bruce, Sr. and David, were suspected of being involved in the sniper slaying of Kennett Square policemen, William Davis and Richard Posey, in the early morning hours of November 15, 1972, but the two Johnstons were never charged. Another gang member, Ancell Hamm, was the only person charged and convicted of killing the two Kennett Square law enforcement officers. Hamm is serving life imprisonment sentences. Johnston, Sr. admitted he was the get-away driver for Hamm and David Johnston aided Hamm during the early-morning assassinations, according to Johnston, Sr.'s brother-in-law Roy Myers.

A federal grand jury looking into the Johnston brothers' theft ring gained traction after Bruce A. Johnston, Jr. turned against his father and uncles and began cooperating with law enforcement. The reason Johnston Jr. turned on his family was that while Johnston, Jr. was in prison on theft charges, his father, Johnston Sr., raped his 15-year-old girlfriend, Robin Miller.

Johnston, Sr. tried and failed to dissuade his son from giving evidence against the family criminal enterprise. Johnston, Sr. then ordered a hit on his son. David and Norman Johnston, Johnston, Jr.'s uncles, agreed to do the killing and ambushed Johnston, Jr. and Miller in the early morning hours of August 30, 1978, after they returned from a date at Hershey Park. Johnston, Jr. survived multiple gunshot wounds, but Miller died of a single gunshot wound to her chin area.

Miller's murder launched an aggressive investigation that resulted in Johnston, Sr. being charged and convicted of six counts of first-degree murder. David and Norman were convicted of being involved in four of the killings. All three received multiple life imprisonment sentences.

Hollywood made a movie of the case, *At Close Range* with Sean Penn and Christopher Walken, and later a factual book on the

case, *Jailing the Johnston Gang: Bringing Serial Murderers to Justice*, was published by Barricade Books.

Richter and Cloud were two of the prime investigators in the in the murder cases. One of the Johnston gang associates was Bennie LaCorte, the same person who asked Jimmy Lynch about the Wyeth paintings.

LaCorte was known mostly as a fence of stolen goods. One of his notable crimes took place in November 1974 when a trailer loaded with food was stolen from the Acme in Oxford, Pennsylvania. The gang members tried into break in a safe at the Acme but could not do so. Instead, the gang stole the food. Some of the stolen food was stored in LaCorte's home. One law enforcement officer said LaCorte's place looked like a grocery store.

J. R. Campbell is a former Pennsylvania State Policeman, Chester County Detective and investigator on the Johnston murder cases. He remembered the first time he met LaCorte. "I stopped him for speeding in the Coatesville area," Campbell said. "He was driving an old Chevrolet El Camino car and it was filled with used carburetors." Where LaCorte gathered all those carburetors was a mystery but he was in the vicinity of a scrap yard that had been a victim of thefts. "I asked Benny where he was going," Campbell said. "He said he was going to a scrap yard in Baltimore, a two-hour drive, because he got a better price." Campbell didn't believe LaCorte for a second.

When Campbell indicated he knew LaCorte and his reputation, LaCorte responded, "Is that a problem?" Campbell answered, "It is with some people." Years later LaCorte admitted he and fellow criminal Bowman Darrell stole Ford car parts from a Modena, Pennsylvania, scrap yard, Lauria Brothers. The company planned to melt down the parts and sell them as scrap metal. LaCorte said they committed burglaries at the company 15 times.

Later in life LaCorte turned away from his life of crime, as he was a licensed chiropractor and barber. Earlier in his life, LaCorte spent time teaching in the Oxford, Pennsylvania, school system. LaCorte spent many days cutting hair in a Kennett Square

barbershop close to the location where the two Kennett Square policemen were killed. LaCorte continued his employment in the barbershop until he became too ill to do so. He died in Florida on June 16, 2018.

After Richter and Cloud talked to Lynch, the Wyeth theft became their case. The two law enforcement officers had the experience and knowledge of the southern Chester County world of crooks. "In my mind," Cloud said, "we had to determine if the remnants of the Johnston gang were responsible for the Wyeth theft. At that point, it wouldn't have surprised me." Richter concurred. "There weren't many high-end burglars in southern Chester County."

Before the investigation was concluded, the search for the stolen paintings would expand far beyond the borders of Chester County. The case was much more sophisticated than the Acme burglary where the stolen goods were hidden in LaCorte's basement. The investigators needed resources to properly investigate the case and federal, state and local agencies supplied the necessary manpower.

The stature of the victims, the Wyeth family, aided the investigators. "The Wyeth name is prominent," Richter said. "It was a worthy case from the get go" to invest the resources, according to Richter.

After the interview with Lynch, Richter and Cloud headed straight to the Wyeth estate and met with Betsy Wyeth.

Before arriving at the Wyeth estate, Cloud recalled the days when he visited the Wyeths with his grandmother Edith Betts, Andrew's school tutor, and aunt Lydia Betts. Cloud was called "little Tommy Cloud" by the Wyeths. On the day the investigators first visited, Cloud remembers Betsy greeting the police officers and saying "big Tom Cloud" was there. "I was holding my breath trying not to be 'little Tommy Cloud,'" the state policeman recalled. Young Andrew gave Cloud's parents a pen and ink drawing, *The Crusaders Before Jerusalem*, when they married in 1931.

The Wyeth family and staff cooperated during the investigation and complied with the requests by law enforcement. "We received beautiful information on the paintings," Richter said. "They gave us photos and the measurements of the paintings. They had great documentation on each painting, including distinguishing marks. Everyone with valuable paintings, and other personal items, should keep such records."

The meticulous records were a key part of the early investigation. Within a day of the theft, major auction houses, art experts around the world, newspapers and the general public knew of the theft. Detailed information and photographs of the stolen paintings were on the front pages of many newspapers. Nicholas Wyeth, Andrew and Betsy's oldest son, used his contacts in the New York art world to spread the word about the theft.

The images of the 15 paintings were suddenly world famous.

If the crooks hadn't pre-sold the artwork, selling them in a legitimate venue would be almost impossible. While turning the paintings into cash might be a problem for the criminals, the publicity had a possible downside for investigators. The hot paintings could be stashed in a basement, attic or other small place for years before they would resurface and an attempt to sell them would be made. Maybe a collector was enjoying the paintings in a room only the owner could visit. The paintings could also be destined to be destroyed if they were deemed to have no value.

Richter remembers the initial meeting with Andrew. Andrew offered to have them take a look at the Granary where the theft took place. The Wyeths were again using the alarm system, Richter recalled, but the code selected was very rudimentary. "It was 1-2-3-4-5, or something like that," Richer said.

Andrew joined Richter and Cloud as they made their way through the crime scene. "When we were on the second floor, where the painting the *Writing Chair* had hung before being taken from the wall, Andy became visibly upset," Richter said. "Andy said he was considering moving from Chadds Ford because he was

so disgusted with the theft of their personal collection, including one of Jamie's first paintings."

James Duff, who was executive director of the Brandywine River Museum of Art at the time of the theft, recalled the whole Chadds Ford community being upset. "The crime was a personal violation. Everyone felt less secure. Important pieces of art were taken. This was not a casual theft. Important pieces of American art were missing."

Betsy joined Andrew in expressing disgust with the invasion of their personal space. "It was a sinking feeling," Betsy said. "The door was open, and I couldn't believe I left it open. It was an intrusion into our privacy. They were all gone. I didn't like those blank spaces on the wall."

Neither of the Wyeths had any idea of those responsible for the thefts. Andrew believed the culprits were professional thieves but not art thieves. Betsy added, "He knew what he was doing. He was very orderly. There were no open drawers."

During the investigation, Betsy remained suspicious of acquaintances, even of friends. She was the Wyeth family member who kept abreast of the progress of the investigation.

Chadds Ford artist Karl Kuerner, whose grandfather was a model for several Andrew's paintings, had wondered if Betsy had at one point thought he might know something of the theft. The day before the theft Kuerner and his wife Louise went to the Granary to borrow back one of Kuerner's paintings for a show the young Kuerner was having at the Chadds Ford Gallery. Kuerner was the only non-Wyeth privately tutored by Andrew and Carolyn Wyeth, Andrew's sister. Kuerner created a painting of Carolyn that Betsy had purchased.

"I wanted to include the painting of Carolyn in my show and I called the Wyeths," Kuerner said. "Betsy told me to come and get it. Louise and I drove to the Granary and my painting was hanging in the same room where all of the ones were stolen. When I departed I asked Betsy if she wanted us to lock the door. Betsy said, 'No, don't worry about it.'

"The next day Carolyn came by and said Andy was robbed. I looked at Louise and said we were just there. The paintings were cleaned out of that one room. How convenient we got ours out. I wondered if they thought about that. The Wyeths never mentioned the coincidence and we were never questioned by the police."

Andrew had a different attitude towards the thefts than his wife Betsy. Cloud said, "Andy could give a hoot. He was low key as he always was." At one point Andrew commented he could always create more paintings. In the Wyeth family Andrew was the creative artist and Betsy the business person. Andrew didn't seem to care or know about the monetary value of his paintings.

* * *

Law enforcement needed a monetary value placed on each painting so the type of crime being investigated could be determined. A petty theft is a lower grade of crime and carries less of a penalty. Petty crimes also generate less attention from police. For the U. S. Attorney's office and the FBI to be involved a certain minimum value had to be involved.

"When we first asked Andy, he put a low value on all of the paintings," Richter said. "He said maybe $3,000 or $4,000 for each one." In reality, Andrew's paintings were worth hundreds of thousands of dollars at the time. Cloud added that a pen and ink drawing Andrew did for his grandparents a number of years before the theft was valued at $3,000.

Andrew totally underestimated the value of his work. *Ericsons*, a painting by Andrew that was completed almost a decade before the theft, was sold for $10.3 million at the auction house Christie's in New York City on May 24, 2007. Another painting done in 1960, more than two decades before the theft, *Above the Narrows* went for $6.9 million at Christie's on December 2, 2009. After the 2009 auction, Christie's wrote, "The price is the second highest ever achieved for a painting by Wyeth at auction, further

demonstrating Christie's continued leadership in the market for works by this celebrated master of American realism."

Six paintings from three generations of Wyeths sold for more than $2 million at an auction at Christie's in 2013. A New Jersey businessman sold his collection of three by Andrew, two by Jamie and one by N. C. The 1938 painting by N.C. was *Norry Seavey Hauling Lobster Traps Off Blubber Island.* The work was of a fisherman off the cost of Port Clyde, Maine.

In court documents the government conservatively estimated the value of the stolen paintings in 1982 to be about $750,000. Even in the 1980s, the haul would have generated multi-millions of dollars at an auction.

* * *

The next logical investigative step was to confront Benny LaCorte, who was a prime suspect because of the conversation he had with Lynch and his prior association with the Johnston gang. LaCorte had another tangible connection to the Wyeths, he had been on their property and had cut Jamie's hair.

Richter and Cloud decided to hold off on approaching LaCorte for the moment. Cloud said, "Benny was off and on hostile towards us. He was in one of his hostile periods."

In the early days of the investigation, law enforcement had a good idea of at least one criminal involved in the theft. Where were the 15 pieces of stolen art? That was the big unanswered question. Were the Wyeth paintings still in Chester County? Maybe they were elsewhere in the United States or transported to some other part of the world. Were they already sold and in the hands of a private collector? Were they destroyed?

"The whole world was the criminals' market place," Richter said.

A lot of detective work was ahead of Richter, Cloud and the rest of the investigative team.

· 4 ·

FOREIGN INTRIGUE

After newspaper, television and radio outlets disseminated reports of the Wyeth theft, law enforcement agencies were bombarded with sightings of the suddenly famous pilfered paintings. During the early stages of the investigation, tips from the public were many and provided conflicting information. The simultaneous and contradictory sightings placed the paintings in Chester County, Delaware and faraway locales outside the borders of the United States.

Just where were the 15 stolen paintings? The question haunted the investigators and the Wyeths.

An early sighting placed the artwork in nearby West Chester, the county seat of Chester County. West Chester is home to art and antique collectors and galleries and has its own criminal underground. Wyeth paintings were, and continue to be, extremely popular in West Chester and throughout all of Chester County. Maybe the paintings were hiding in plain sight in Wyeth country.

Another tipster reported the paintings had crossed state lines and were in Delaware. If the paintings did leave Pennsylvania, the federal government's jurisdiction was clearly established. The FBI

investigates interstate transportation of stolen goods and the U. S. Attorney's office prosecutes the cases. Maybe the paintings were in Delaware, in du Pont country.

The Delaware state line is only a short drive from the site of the crime. Northern Delaware and suburban Wilmington are affluent areas of the country. The area is part of the Brandywine Valley, a scenic part of the country enhanced by the estates of members of the du Pont family and the generosity of those associated with Delaware's Du Pont Company. World famous Longwood Gardens, a former du Pont estate, is only a few miles from where the Wyeths lived. The Wyeth paintings could easily find a home in Delaware.

Police diligently followed the local leads and found no substance to the reported sightings. The paintings weren't hanging in plain sight at least. Richter succinctly summed up the first flurry of tips: "They were wrong."

Where were those paintings? Persistent rumors were circulating that the paintings were no longer in Pennsylvania, Delaware or any other part of the United States. Concerns existed that the artwork was in Europe or Asia where buyers of stolen artwork lived. As with the local sightings, no solid evidence existed as to the whereabouts of the stolen art in Chester County or the world.

During the 1980s, The *Associated Press* reported internationally stolen art ranked second only to narcotics in generating illicit income. Thieves targeted works of the great masters, such as Rembrandt and Van Gogh. Wyeth, and other well-known artists were also targeted. The International Foundation for Art Research in New York reported 4,150 pieces of art were stolen in just one year, 1984. Earlier in that decade the total number of art pieces taken by thieves numbered only about 2,000.

"We weren't about to rule out anything," said Assistant U. S. Attorney Jack Riley. "All possibilities were on the table. We were doing everything we could to narrow the focus. Were they in Monte Carlo or Kennett Square?" The venues Riley mentioned were certainly different, with Kennett Square in Chester County

being the mushroom capital of the world and associated with the growing of the fungus while Monte Carlo featured famous glitzy casinos on the French Riviera, populated with wealthy visitors.

Law enforcement hoped the artwork hadn't become part of the murky and lucrative international world of art crime. Once works of art disappeared, decades could elapse before they were discovered, if they were recovered at all.

Riley and colleague Assistant U. S. Attorney Walter "Terry" Batty, Jr., were aware the criminal suspects, including LaCorte and a notorious fence of stolen property, Francis Matherly, had contacts in New York City and with those associated with organized crime. "Franny and his contacts knew just about everyone involved in illegal activity, including gambling, loan sharking and organized crime. They had the contacts and all doors were open to them," Richter said.

Easily the criminal network could extend overseas and into the nether world of art thefts. "The investigation could have turned into one of an international scale," Riley said. Indeed, the international law enforcement agency Interpol located in Lyon, France, was contacted after the theft. There was suspicion that the paintings could have traveled through Rome, London or Tokyo. One officer said there was a fear the art had gone underground with an individual art collector and would never resurface.

Another fear was that if the criminals couldn't sell the paintings the artwork would be destroyed. If the paintings couldn't generate income and became evidence against the thieves, the criminals wouldn't hesitate to slash and burn the 15 pieces of cherished artwork.

Art theft is a lucrative field. The FBI estimated in 2017 that thieves steal between $4 billion and $6 billion worth of art each year. The thefts are committed in galleries, museums and private homes. Some of the paintings, sculptures, antiquities and other artistic items are taken to be privately viewed but most likely they are pilfered to be sold. While the proceeds lined the pockets of the crooks, some of the money from stolen art has been used to fund

terrorist organizations. And some of the reported thefts were not thefts at all, but insurance scams.

For the public, on the other hand, art theft has a glint of glamor. After all, art is created by talented and famous persons, their creations are worth small fortunes and museums and private home showing the works are located in exotic localities. A popular movie of the genre is *The Thomas Crown Affair*. The original movie was made in 1968 and stared Steve McQueen and Faye Dunaway while the 1999 remake starred Pierce Brosnan and Rene Russo with Dunaway playing a secondary character. The movie featured all the Hollywood glamor associated with the crime. The Wyeth art theft wasn't glamorous, and most art thefts aren't.

The biggest art theft ring, and the most brutal, was run by the Nazis before and during World War II. Art was plundered and confiscated from museums, churches and private homes across Europe. Nazis reportedly stole a fifth of all known artworks in Europe. A book and documentary film, *The Rape of Europa*, details the thefts and the efforts of Allies to return the art. Some of the masterpieces have not been recovered after more than seven decades and many were destroyed. The whereabouts of more than 100,000 pieces of art are unknown. Another book and movie, *Monuments Men*, details efforts of the United States military at the end of World War II to secure and return stolen artwork. The military unit had the support of President Franklin Roosevelt and General Dwight Eisenhower.

Ownership of many of the pieces of recovered stolen art remains disputed. Hundreds of pieces of stolen art were held by governments for many years. Dealers and museums retained artwork, hoping to legitimize ownership or quietly sell pieces. One famous case brought by Maria Altmann ended up in the United States Supreme Court. Altmann sued the Austrian government over the ownership of Gustav Klimt's *Adele Bloch-Bauer I*, known as the *Woman in Gold*. Altmann was Blouch-Bauer's niece and the painting was in her family's possession when confiscated by

the Nazis. A disputed will left the 1907 portrait to an Austrian museum. The painting was finally deemed to belong to Altmann. The painting was sold in 2006 for $135 million.

The BBC reported, "It might be thought that, almost 70 years since World War II ended, problems of art looted during the conflict had been resolved. Far from it. The issue remains extremely complex, with thousands of Nazi-looted works still hanging on museum walls or hidden in private collections. But who is to blame if someone finds a looted work in a collection? The original collectors are generally deceased, and the works may have been legitimately traded many times since WW II — so who is at fault? How can claimants prove they were war loot anyway? And is it legitimate for 'art detectives' to charge fees, sometimes in the millions of pounds, to track down and return such works of art to their rightful owners?"

The BBC story was sparked by the discovery of more than 1,400 artworks in the Munich home of Cornelius Gurlitt, who died in May 2014 at the age of 81. His father Hildebrand Gurlitt had been an art dealer to the Nazis, and at least some of the works he had in his two homes were looted from Jewish families.

The group stealing the Wyeth paintings certainly wasn't on a par with the Nazis, but the successful Wyeth theft rivaled some other famous art heists, including the still unsolved heist of 13 pieces of art from the Isabella Stewart Gardner Museum in Boston on March 18, 1990. In the early morning hours two men disguised as police officers gained entrance to the museum and overpowered two young college security officers. The thieves spent about 90 minutes in the museum taking paintings, including ones by Rembrandt, Degas and Vermeer. The value of the paintings has been estimated at more than $500 million and represented the largest property crime in United States history.

Many theories exist as to the identity of the thieves and the location of the paintings, which still haven't been located. A retired FBI agent told reporters he believed two of the stolen prints went from Miami to the south of France. The museum

offered a $5 million reward for the return of the stolen art and at one point doubled the reward. Like the Wyeth pieces, the paintings have been reported to be in many locations along the east coast, including Philadelphia. Also like the Wyeth thieves, links to organized crime existed.

There is another Wyeth connection to the Gardner theft. Myles Conner, who has been publicly labeled a "notorious art thief," was linked to the theft of an Andrew painting from the Woolworth estate in Monmouth, Maine, in 1974. Frederick Woolworth, a family member of the founder of the Woolworth department store chain, was a New York art gallery owner who handled Wyeth artwork. Conner also claims knowledge about the Boston theft from the Isabella Stewart Gardner Museum.

Another similarity between the Wyeth theft and other famous thefts was the lack of security protecting the artworks. In 1985 a thief walked into the Fine Arts Museum in La Coruna, Spain, and took two small paintings by 17th century Flemish master Peter Paul Rubens from their frames. The thief then walked out of the museum before anyone discovered the theft. The museum had no security system. The museum in La Coruna, Spain, and the Wyeth family estate in Chadds Ford, both tightly secured their precious paintings after the thefts.

Both paintings by Rubens were recovered. The first one was recovered fairly quickly from a Mexican citizen believed to be the thief. He fled before he could be sent to prison. The FBI was tipped off to a woman trying to sell the second stolen painting in Miami. She had smuggled the Rubens into the country from Nicaragua. The FBI conducted a sting operation at the Ocean Grand Hotel on Miami Beach and arrested the woman and others involved but not the thief.

The Wyeth theft also had something in common with the heist of one of the most famous paintings in the world, the *Mona Lisa* by Leonardo da Vinci. Italian handyman Vincenzo Peruggia walked into the famous Paris museum, the Louvre, in August 1911 and walked out with the painting. Like the Wyeth theft, the crime

wasn't discovered until the next day. Like the Wyeth theft, a suspect was someone who worked at the site of the crime.

Peruggia had worked at the Louvre and knew operational details. He went on a day the museum was closed to the public for cleaning and brazenly acted as if he was still working at the Louvre. He took the painting from its frame and walked out undetected. Peruggia claimed he was attempting to return an Italian masterpiece to his home country. He was arrested two years later in Florence and spent a year in prison. The *Mona Lisa* was eventually returned to France and the Louvre.

Another notorious theft was eerily similar to the Wyeth theft. The thief, an alarm systems specialist who installed alarms for clients, took advantage of an inadequate security system. Robert Mang broke into the Vienna Art History Museum in 2003. Instead of using a ladder, as was the case in the Wyeth theft, Mang climbed construction scaffolding at the museum to enter a seventh-floor window.

Mang set off a window alarm but guards believed it was a malfunction as numerous malfunctions took place with the museum's security system. The guards reset the alarm without investigating. Within minutes Mang was back on the scaffolding with a 16th-century gold-plated sculpture by the Florentine master Benvenuto Cellini. *La Saliera, Salt Cellar,* was valued at $65 million, and contained depictions of Neptune, the sea god and Ceres, the goddess of agriculture. The artwork was created between 1540 and 1543 on commission from King Francis I of France, and is Cellini's only remaining authenticated gold work.

By chance, Mang went into the art museum a few days before the theft to attempt to meet a woman he saw visiting the museum and noticed the alarm system was out of date. He thought *La Saliera* would be easy to steal and it was. After an attempt to sell the piece to an insurance company failed, Mang threated to melt down the sculpture but did not do so. Mang was captured three years after the theft after police identified him through his use of a cell phone.

The Wyeth paintings vanished the same way as thousands of other artistic treasures every year. The theft from the Granary wasn't the first time Wyeth paintings had been targeted by thieves, nor the last.

Andrew's painting *The Studio*, completed in 1966, was stolen in 1967 from the Sears Vincent Price Art Gallery in Chicago. Actor Vincent Price, an art aficionado, purchased the Wyeth painting for $27,000 and placed it in the gallery, a joint venture between Price and the Sears company. A thief simply lifted the painting of Wyeth's own studio in Chadds Ford off the Chicago gallery's walls and walked out onto Ontario Street. The painting disappeared until 2000 when it was placed in auction at Christie's. The auction house determined the painting was stolen and alerted law enforcement. The FBI announced its recovery in February 2001.

In 2000, Andrew's watercolor *A Bridge, Race Gate* was stolen from a private collection in Houston along with more than 20 other paintings. In 2008 the watercolor was brought into the Simpson Galleries in Houston and offered for sale. The gallery had handled Wyeth works in the past and sensed something was wrong about the offering. The Art Loss Register of London was contacted and verified the painting was stolen. A police sting resulted in an arrest and the recovery of the Wyeth painting.

Two of N. C.'s paintings for book illustrations were among six items stolen from a home in Maine in 2013. Four were recovered in a Beverly Hills, California, pawn shop but N.C.'s paintings, *Go Dutton, and That Right Speedily* and *The Encounter On Freshwater Cliff* were not among those recovered. A $20,000 reward was offered at the time of the theft.

There are also forgeries of Wyeth artwork floating around the country. The FBI seized one of the work *Wreck on Doughnut Point*, a 1939 watercolor by Andrew, after the artist died. The fake had been offered for sale several times. At one point Andrew declared the painting a rank forgery. The man attempting to sell the forgery believed it was a genuine Wyeth painting.

The FBI reported seven forgeries surfaced within months of

Andrew's death. Another Wyeth fake taken out of circulation was the 1970 painting *Snow Birds*, offered for sale at Christie's. A dealer who had recently been involved in the sale of the real *Snow Birds* alerted Christie's to the offering of the fake *Snow Birds*. The fake was ordered destroyed.

"Unless you take these forgeries and drive a stake in them and then burn them, they keep circulating," said Ronald D. Spencer, a New York lawyer who edited a 2004 collection of essays on fake art, *The Expert Versus the Object.* "Stolen art always makes newspaper headlines, but it's not as prevalent a problem as forgery, because stolen art is harder to resell."

Wyeth theft investigators were blazing somewhat new trails when they began searching for the missing artwork. National and international organizations specifically designed to investigate art theft hadn't been established when the Wyeth paintings were stolen from the Granary. Most of the special art units wouldn't be formed for more than a decade.

The FBI began an Art Crime Team in 2004. More than a dozen agents are coordinated through the FBI's Art Theft Program, headquartered in Washington, D. C. Members of the art unit receive specialized training in art and cultural property investigations both nationally and internationally. In a little more than a decade the FBI Art Crime Team has recovered more than 1,000 items with a value exceeding $135 million.

The recovered works of art included, according to the FBI, more than 800 pre-Columbian artifacts taken from archaeological sites in Panama and Ecuador, a 15th-century map taken from the National Library in Spain, three paintings by German painter Heinrich Buerkel, stolen during World War II and offered for sale at an auction house near Philadelphia in 2005 and two paintings by Rembrandt, Rembrandt's *Self Portrait* and *The Young Parisian*, stolen from the Swedish National Museum in Stockholm in 2000.

Some big cities in the United States also have art theft squads, including the Los Angeles Police Department. The Los Angeles unit reported more than $121 million in stolen art recovered.

London's Art Theft Register was established in 1990 and helps law enforcement agencies, museums and private citizens recover stolen art. The register is the world's largest private database of lost and stolen art, antiques and collectables. The company's range of services includes item registration and search and recovery services to collectors, the art trade, insurers and worldwide law enforcement agencies.

Satellite offices were subsequently opened in New York, Cologne, Amsterdam and Paris to cater to growing client bases in these countries. In January 2010 the Art Theft Register consolidated the regional offices in to one central, international office, run from London. The organization reported being instrumental in the recovery of hundreds of millions of pounds worth of stolen valuables.

As the investigators began their search in earnest, they knew the Wyeth paintings could be anywhere in the world or nowhere in the world. The immediate intense publicity after the theft devalued the paintings on the black market and negated the possibility of an open sale at an auction or gallery. Rather than be caught with stolen property with no value and risk being sent to prison, the thieves might opt to get rid of the pieces.

Hildebrand Gurlitt 1925, Was a dealer to Nazi's and had looted the Nazi artworks.

Cornelius Gurlitt son of Hildebrand Gurlitt, used to sit in the dark with masterpieces of art — many of them stolen. They were his only companions after his parents and sister died.

Hildebrand Gurlitt

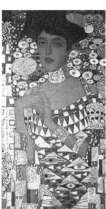

Adele Bloch Bauer I

The Woman in Gold or *Portrait of Adele Bloch Bauer I* by Gustav Klimt.

Marie Bauer Altmann is noted for her successful campaign to reclaim from the Austrian Government five family-owned paintings by artist Gustav Klimt, stolen by the Nazi's.

Robert Mang. Art Thief. Stole a Cellini 16th Century Gold Plated Sculpture.

La Saliera / The Salt Cellar by Benvenuto Cellini

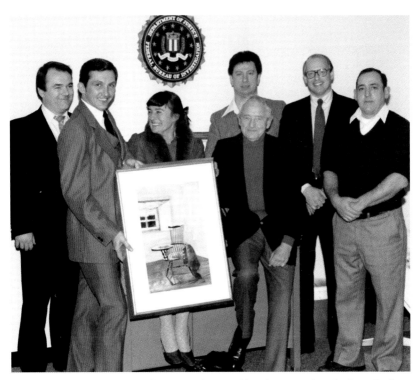

L-R. Pennsylvania State Policeman Thomas Cloud, Pennsylvania State Policeman Robert Martz, Betsy Wyeth, Andrew Wyeth, Pennsylvania State Policeman J. C. Campbell, Chester County District Attorney James Freeman and PA State Policeman Paul Yoder.

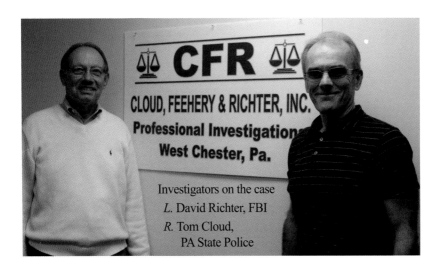

Members of the U. S. Department of Justice. *L.* Standing are: Assistant U.S. Attorney Terry Batty, who prosecuted the case; Tom Mellon, Chief, Criminal Div. of the U.S. Attorney's office, Philadelphia. *L.* Seated are: Assistant U. S. Attorney Jack Riley, who prosecuted the case; Ed Dennis, became Assistant U.S. Attorney General, Criminal Div., Washington, D. C., under Attorney General Ed Meese.

Dennis titled this photo "Princes of the City."

L-R. Special Agent in Charge of the Philadelphia office of the FBI John Hogan, Jamie Wyeth, Betsy Wyeth, Andrew Wyeth and FBI agent David Richter. Nicholas Wyeth is kneeling in the foreground

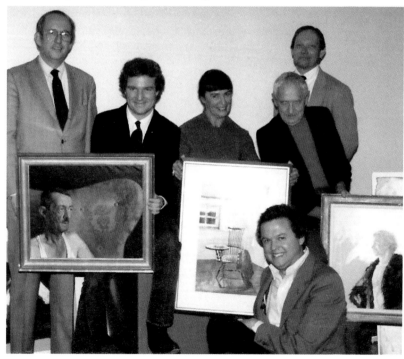

N. C. Wyeth in his studio
ca. 1903-1904.
Father of Andrew and
Grandfather of Jamie

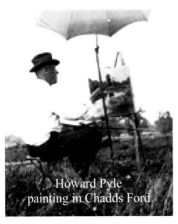

Howard Pyle
painting in Chadds Ford

Howard Pyle, instructor to
N. C. Wyeth,
with daughter Phoebe

N.C. Wyeth on his Chadds Ford property,
ca.1943. Photograph by Edward J. S. Seal,
Courtesy of the Wyeth Family Archives

Andrew Wyeth
Writing Chair 1961.
Drybrush watercolor
on paper.
The Andrew and Betsy Wyeth
Collection.

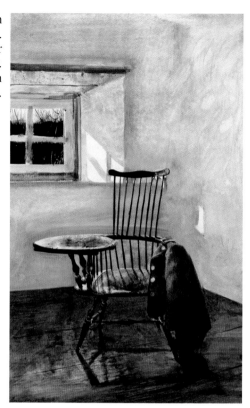

Jamie Wyeth
*Profile Head, Nureyev (Study
#8)*1977. Gouache and pencil
on toned paper board.
Private Collection.

Jamie Wyeth
*Profile In Fur, Nureyev
(Study #9)* 1977.
Gouache,
ink and pencil on
toned paper board.
Private Collection.

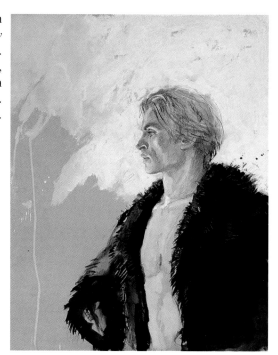

Andrew Wyeth *Grey Mare* 1979. Watercolor on paper.
The Andrew and Betsy Wyeth Collection.

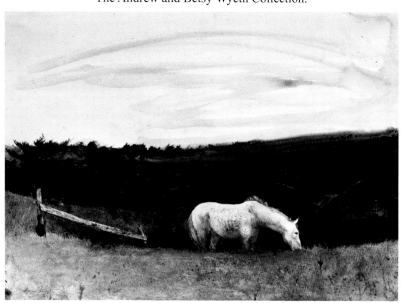

Andrew Wyeth, *Baron Philippe* 1981. Watercolor on paper.
Private Collection

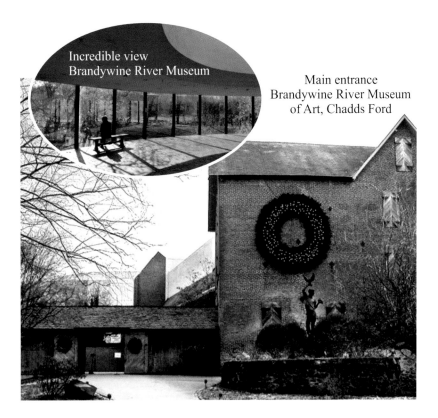

Incredible view
Brandywine River Museum

Main entrance
Brandywine River Museum
of Art, Chadds Ford

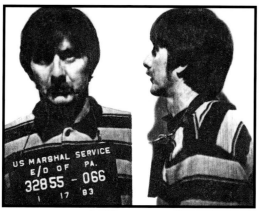

William Porter was the master cat burglar who committed the Wyeth burglary. An installer of burglary alarms by day, he admitted to taking part in 1,500 thefts during his criminal career.

William Porter

Doug Fuller

Francis Matherly was the fence who was a master at selling stolen goods. He was also the getaway driver on the night of the Wyeth theft.

Franny Matherly

Doug Fuller was a Chester County criminal who was entrusted with hiding some of the stolen Wyeth paintings. He committed suicide before the trials of the criminals began.

Benny LaCorte was a school teacher, barber, chiropractor and thief. He had the idea of stealing a Wyeth painting.

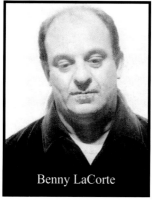

Benny LaCorte

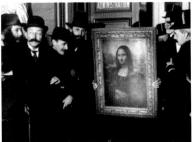

Vincenzo Peruggia and the theft of the *Mona Lisa*

George Weymouth became a confident and friend of Andrew Wyeth and is one of the founders of the Brandywine River Museum.

Kuerner Farm, also known as Ring Farm, is a historic farm in Chadds Ford notable for its association with Andrew Wyeth, who created about one-third of his work, over 1,000 paintings and drawings, on subjects he found there over a span of 77 years.

Chadds Ford Inn Today

**Notes

·5·

TENNESSEE BOUND

Some of the tipsters were correct; the Wyeth paintings didn't stay long in Pennsylvania and did travel through the neighboring state of Delaware. Immediately after the theft the stolen artwork was taken to Franny Matherly's home in Newark, Delaware. Franny's kitchen was the location where the original idea for the theft was formulated.

In a letter written by Benny LaCorte from prison on December 3, 1985, to West Chester *Daily Local News* reporter Bruce Mowday, LaCorte described how the theft was planned. LaCorte wrote that about two weeks before the theft he visited his criminal cohort Franny and mentioned a Wyeth painting was sold for about a half million dollars at an auction. LaCorte, in one interview, said Porter was present at the meeting.

"We should try to get a couple," Franny commented. LaCorte responded that one or two would be nice. LaCorte then volunteered that the old mill on the Wyeth property on Creek Road, the Granary, probably had a few. LaCorte should know as he was inside the Granary at one point with Jamie to cut the young Wyeth's hair. Franny told LaCorte he would think about stealing the paintings.

Later Franny and LaCorte deliberately drove past the Granary as they were returning from a trip to West Chester. LaCorte pointed out the building where he was sure Wyeth paintings existed. "I had no idea that a prized collection would be at the mill, but I was certain something would be there. The original plan was to get one or two," LaCorte wrote Mowday.

The night before the burglary Franny, LaCorte and Porter met at Franny's home at 1000 Marrows Road, Newark, Delaware, to discuss the burglary. LaCorte drew a map of the Wyeth estate and told Porter where the paintings were stored. LaCorte emphatically designated the "left-hand building at the rear of the property," the Granary, as the location of the prized artwork.

* * *

After the last painting was secured in the truck along with Porter's ladder, Franny told Porter they had a fortune in Wyeth paintings in their possession. The robbers arrived at Franny's home about midnight and began unloading the stolen paintings. They also phoned LaCorte.

LaCorte's first thought was that the whole Wyeth collection had been cleaned out, according to Porter. LaCorte immediately had second thoughts. He knew the magnitude of the theft would bring the wrath of law enforcement on their heads. LaCorte advised Porter and Franny to "pack them all up, put rope around them, wrap them in a tarpaulin and take them back." LaCorte indicated he had second thoughts about the crime because the Wyeth family was well-connected, even knew the President of the United States, and that the Wyeths would "go to the ends of the earth" to recover the paintings.

Porter and Franny weren't about to return the paintings. The criminals considered the stolen artwork their "retirement fund." They hadn't thought ahead about pre-selling the paintings. As Andrew Wyeth stated to police, they weren't professional art thieves.

Franny, the professional fence who made a living selling valuable objects large and small, went to work that night contacting people about purchasing the Wyeth paintings. He failed to find a buyer. Porter tried his hand and called his fellow Tennessee criminal contact Glen Barnett to see if another local criminal, Kenneth Blevins, would be interested in purchasing the paintings. Porter asked for $300,000. No deal was made.

Porter returned to his hotel, paid $32 for another night and left a wake-up call for 8:00 a.m. The next morning Porter returned to the Matherly home. They couldn't find any news coverage of the theft and thought the crime might not be discovered until the next day, Monday. If so, the criminals would receive a break as they would have another 24 hours to slip far away from Wyeth country.

Only 12 of the works of art would fit into Porter's red Ford Mustang for the trip back to Tennessee. Toys were placed on top of the paintings in attempt to make the pile look like the car was transporting family items. The remaining three paintings were left in the care of Franny and LaCorte and for the moment were stored in LaCorte's car, a Lincoln.

Back home in Tennessee Porter didn't want to have the hot artwork discovered in his home. The burglar was afraid someone might double-cross him, or he might be arrested in connection with another burglary. Porter loaded the Wyeth paintings into the trunk of a 1954 Ford he owned. Thomas Keller, a Porter friend, towed the car to property owned by Jackie Coggins, another Porter friend. Keller was paid in building materials for the towing operation.

Porter continued to try to make a deal with Blevins. Porter's asking price for the paintings dropped to $150,000. At one point, according to Porter, Blevins removed the paintings from the car and put them in a storage building.

Art connoisseurs would have been outraged to know that instead of gracing the walls of a well-known international art museum or an elegant home of a rich private collector, the paintings were kept

in a trunk of an old car near Johnson City, Tennessee, and then a storage locker.

* * *

During the beginning stages of the investigation, no promising potential leads as to the whereabouts of the paintings existed. The possibility the paintings were being held for ransom existed and a wiretap was installed on the Wyeth's phone.

"Dave (Richter) showed Betsy how to use the device to wiretap the phone," Cloud said. "At that time the federal and Pennsylvania wiretapping laws were different. Dave had federal approval. Because of the value of the paintings we thought there might be a ransom call."

If such a ransom request had been made, those close to the Wyeths were convinced Andrew would not have paid a cent. The Wyeths fully cooperated with the recommendations of law enforcement during the investigation. Andrew was especially fascinated about the details of the case and asked for updates from police.

Modestly, FBI agent Richter commented, "We caught lucky breaks along the way." Actually, the investigation was built on hard work, professionalism and knowing the Chester County criminal underworld. Luck had little do with the investigation but the investigative team did get several breaks along the way.

The first major break dealt with a violent dispute within the Matherly-Madron crime family.

On April 21, 1982, less than a month after the Wyeth theft, 18-year-old Robert Allen Matherly, known as Robbie, was hospitalized after being beaten with an ax handle by his father, Noel Allen Matherly. Noel was the brother of fence Franny. Noel became upset after Robbie refused to accompany him on a burglary. In the previous three years, since he was 15 years old, Robbie guessed he had taken part in between 150 and 200 burglaries for his dear old dad.

Pennsylvania State Policeman Tom Cloud summed up Noel by saying he was "a piece of crap." One of Noel's criminal cohorts said Noel had a $75 a day cocaine habit. Noel, who worked at times in a greenhouse and professed to be a preacher of the word of God, and his brother Franny were crooks but very different. Franny was described as being a professional criminal with plans for the future. His goal was a good life for himself and his wife Nancy.

Noel wanted to live like his brother Franny, but he didn't have a clue how to do so. Noel did know how to abuse his family. Another son, Timothy, described years of living in fear of his father, who would mentally, physically and sexually abuse him and his siblings.

Franny and Noel had a brother Larry and a sister Ruth Matherly Madron, who were also involved in the crime family business along with Madron's sons, Gerald, known as Whitey, and John. Pennsylvania State Policeman J. R. Campbell said Larry would spend time in jail and as soon as he was released he would commit additional crimes. "Larry's MO was he used vice grips during the thefts and he would leave striations from the vice grips," Campbell said. He wasn't a smart burglar.

Robbie told police that his father Noel was responsible for getting him into crime. Noel usually compensated his son for committing the burglaries, about $100 for each theft, and provided transportation to the burglary scene. Noel drove Robbie to homes designated to be robbed, dropped off Robbie and returned in about 20 minutes to retrieve Robbie and the stolen goods. Noel was known to be a "chicken" when it came to actually entering a victim's home. Noel needn't have worried about being harmed as Robbie would have offered protection. The young Matherly admitted carrying a loaded automatic pistol with him when he committed crimes.

Robbie said at the time his family lived in the 500 block of East Birch Street, Kennett Square. Besides taking part in burglaries, the father and son also shared drugs. Robbie said he abused

cocaine, methamphetamines, marijuana, alcohol and Quaaludes. At times, Robbie said, he would also purchase drugs from people in his neighborhood and resell the illicit product.

When committing a burglary, Robbie would stuff the money, jewelry, silver, guns and other items of value found in the homes into pillow cases. According to Robbie, the father-son team would take the pillow cases full of stolen goods to family member Franny, who would purchase them from his brother Noel. Robbie said some of the stolen items would be purchased by his aunt, Ruth Madron, again keeping the stolen goods in the family.

At times Robbie would commit crimes with his cousins Whitey and John Madron. Robbie estimated Whitey took part in at least 75 burglaries and John did at least 30. Uncle Larry Matherly joined the cousins at times, according to Robbie. The robbers tried to commit crimes when the victims weren't home. Robbie estimated 90 percent of the crimes took place when the owners were elsewhere.

Robbie's mother wasn't fond of her son's involvement in burglaries, but Noel insisted. The Matherlys were a crime family and Robbie's mother also took part. Admitted burglar, Steven Mark Moody, of Kennett Square told police that Robbie's mother Tillie would fill the family car with gas for them when a crime was to be committed and one night fetched the tool bag for them that was to be used during a burglary.

The time Robbie was hospitalized after being hit with an ax handle wasn't the first time Noel had beaten his son for refusing to rob with him. The ax handle beating would be the last. Robbie began cooperating with law enforcement officials and was put under police protection.

On May 6, 1982, Robbie gave a statement to Pennsylvania State Policeman Campbell and New Castle County, Delaware, policeman Dennis Godek. Campbell had had previous contact with Robbie and had been talking to the young burglar before his father beat him with the ax handle.

"Robbie called me, and I went to the hospital," Campbell said.

"He began to give me some information on his family's life of crime and indicated he had information concerning the theft of the Wyeth paintings. He said his aunt Ruth Madron had them at one point. He said he wasn't involved in the Wyeth theft and didn't know the location of the paintings, but he did hear family members talking about the theft.

"Robbie was convinced members of his family would visit him in the hospital and offer him money in an attempt to persuade him to stop talking," Campbell said. "He implored me to do something to protect him. That is when I secured guards for Robbie."

Assistant District Attorney James P. MacElree, II, later a Chester County Common Pleas Court President Judge, joined Campbell on one of the early visits to see Robbie. MacElree said, "Robbie decided we were going to be his family since his own family didn't like him anymore."

The prosecution team quickly made arrangements to have Robbie testify before the grand jury. Robbie testified on May 12, 1982, in Philadelphia. "We wanted his statements memorialized," Cloud said. Law enforcement needed the information and didn't want to risk additional harm coming to Robbie before his story was on the record. To keep Robbie from harm, the Pennsylvania State Police provided protection.

* * *

Two assistant United States attorneys, Terry Batty and Jack Riley, handled the grand jury and federal prosecutions. Both experienced prosecutors were acquainted with Chester County despite working in offices in Philadelphia. Batty handled cases involving the Johnston gang and Riley grew up in Chester County where his father was a judge. Riley also clerked for two county judges, Thomas Pitt and Theodore Rogers, who later became a Pennsylvania Commonwealth Court judge.

"Dave (Richter) called one night," Batty said, "to say Rob-

bie Matherly had been assaulted and was injured. Dave felt the assault would be the crack in the Matherly gang needed for the federal investigation." Riley was assigned to the case to support Batty. "Our office had an ongoing interest in southern Chester County because of the crimes, many pointing to the Johnstons and Matherlys," Riley said. "When it became clear more manpower was necessary, I became involved."

Riley said the "key ingredient" in the federal prosecution was Richter. "Dave bound a lot of elements together for us. He had credibility with the local populace and with the targets of our investigation. There was a broad base of crimes taking place in Chester County, tractor and car thefts, house burglaries, murders and stolen art. Dave had credibility with those committing the crimes, the Matherlys, LaCorte and the Johnstons. Dave's presence was a clear sign that the federal government was going to apply a whole lot of resources. The criminals knew they were not going to be able to hide in the weeds any longer. They had two options, the criminals could test the judicial system and be prosecuted, or they could cooperate. The local and state police were very efficient, but it was just better to have the feds involved. The federal government has lots more resources and a larger jurisdiction. The criminals knew we would provide additional manpower. The criminals knew at some point their doors would be knocked upon by law enforcement officers. It was only a question of when."

Batty gave Richter credit for assembling an efficient investigative team. "I've never seen anything like it before or since, it was extraordinary," Batty said. "Jack (Riley) and I liked all of the members of our team. Over the years you hear of stories where the state police might not be as cooperative in joint investigations, but we received great work from the state troopers. Dave knew every one of them and worked well with them. The same can be said of Charlie Zagorskie and his Chester County detectives. This investigation was a massive undertaking. Dave knew how to plot out and assemble everyone. The criminals knew Dave was capable and they knew when Dave was on the case it was serious business."

Riley added, "In an investigation everyone needs to get along, that is very important. Oftentimes behind the scenes there can be petty jealousies that can interfere with law enforcement. We don't always get the maximum results. In this case we did, and it was largely due to Dave stepping in making sure those jealousies were put aside. It was important to get our job done and not so much who was receiving credit."

According to Richter, the state police troopers were under constant pressure for years because of the number of crimes being committed in southern Chester County. "They had no support and weren't given overtime and manpower," Richter said. "There were limited resources in the Avondale barracks. They had new crimes coming in every day. They were overwhelmed. When I came, I just wanted to work. The troopers were thrilled to team up to get the work done. We also took some pressure off them by having some of the cases go to federal court to be prosecuted." Avondale troopers handled more crimes than all but one barracks in Pennsylvania at the time.

Batty is convinced that without Richter, prosecuting Chester County criminals would have been much more difficult with less positive results.

* * *

Campbell said law enforcement checked out other leads given by Robbie concerning stolen items, hoping for a link to the Wyeth theft. "The Matherlys lived in a house near a rose-growing business near Kennett Square," Campbell said. "There was a dump on the property and a fire pit. Robbie said they used to discard unwanted items from a theft in the fire pit. We checked the pit and did find some stolen goods, but we couldn't tie them to a specific burglary." Timothy Matherly confirmed that his father used to give him and his siblings a "job" of disposing of the unwanted stolen items. Timothy added that a swamp was near the dump and some of the items were discarded there.

"After Robbie was interviewed we had a good flavor of what was taking place," Richter said. "We brought him before a grand jury. That led us to interview Noel. He hired defense attorney Robert Donatoni and Donatoni told him to cooperate."

Donatoni said the federal government had a "very strong case" against Noel in connection with a number of burglaries. "I suggested that Noel talk to the FBI and ask Dave Richter if a deal was possible," Donatoni said. "Noel didn't want to give up his brother Franny, but we did go to see Richter at his FBI office in Newtown Square. A deal was eventually worked out. Dave then called Franny Matherly and told him the police were going to come and see him soon. Dave asked, 'Do we need to bring your brother (Noel)?' That was Dave's way of saying Noel was cooperating."

The first big break in the Wyeth art theft case was eerily similar to the big break that led to the solving of a half dozen murders and hundreds of burglaries in the Johnston case just three years earlier by Richter, Cloud, Campbell and many of the other investigators and prosecutors working the Wyeth case.

"Anger and Robbie's beating by his father led to Robbie's cooperation against family members in the Wyeth case," Cloud said. "In the Johnston case it was Bruce Johnston Jr.'s cooperation against his father and uncles. Johnston Jr. didn't begin to talk until the rape of his 15-year-old girlfriend by his father."

During the summer of 1978 Johnston, Jr. was serving time in Chester County Prison for theft. His young girlfriend, Robin Miller, was offered a ride to visit Johnston, Jr. in prison by Bruce Johnston, Sr. and another member of the Johnston gang. Miller accepted the ride and whiskey offered her during the trip to the prison. She never did see Johnston, Jr. that day. She was raped and left in a motel room. She awoke the next day, naked.

While Johnston, Jr.'s testimony was vital in the solving of many of the burglaries committed by the Johnston gang, his turning on his family led to five murders and an attempt on his life. Johnston, Jr.'s testimony resulted in federal grand jury subpoenas being issued to three young members of the Johnston gang. They

were all killed before they could testify. One of the victims was Johnston, Jr.'s stepbrother, Jimmy Johnston. Gang member James Sampson was murdered after he raised questions about the safety of his brother Wayne, one of the three gang members previously killed. Dwayne Lincoln was the other young gang member killed by the Johnstons.

After Johnston, Jr. was released from prison he refused police protection and spent several weeks with Miller and eluding his father. Johnston, Sr. hired two of his brothers, David and Norman, to kill Johnston, Jr. The uncles of Johnston, Jr. ambushed Johnston, Jr and Miller one night in August 1978 and severely wounded Johnston, Jr. and killed Miller.

* * *

On May 10, 1982, law enforcement investigators prepared to meet face-to-face one of the two robbers who committed the theft, Francis Matherly. The police were unaware that Franny no longer possessed the paintings and that two of the Wyeth creations had already been sold.

Bruce A. Johnston Sr. was the leader of a gang of thieves that specialized in stealing Corvettes and John Deere tractors. He was convicted of six counts of first-degree murder and died while in prison.

Bruce A. Johnston, Jr., cooperated with police after his father raped Robin Miller, the younger Johnston's 15-year-old girlfriend. Johnston, Jr., was severely wounded when his two uncles, David and Norman Johnston ambushed and shot Johnston, Miller died in the ambush.

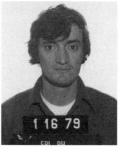

Norman Johnston, youngest of the Johnston brothers is serving multiple life imprisonment terms in connection with convictions of four counts of first-degree murder. He escaped from prison in 1999 but was recaptured close to where he committed three of the murders.

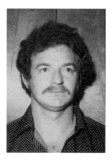

David Johnston was one of the leaders of the Johnston Gang and was known as the most ruthless of the three brothers. He was convicted of four counts of first-degree murder and died in prison.

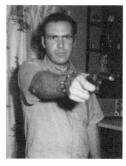

Ancell Hamm, a member of the Johnston gang, was the only person charged and convicted with the sniper slayings of two Kennett Square policemen. He remains in prison.

·6·

DOMINOS BEGIN TO FALL

Mushrooms are a big business in Chester County and have been since the late 1800s. One community, Kennett Square, is known as the mushroom capital of the world. Mushroom images can be seen adorning almost everything in Kennett Square and one store, the *Mushroom Cap*, specializes in everything mushroom.

Families made fortunes growing and selling the delicious fungus. Yearly mushroom sales reportedly total almost $400 million from the approximately 50 farms in the area.

During the 1980s the male owners of the farms, mostly of Italian descent, tried to outdo each other with the luxuries they purchased from their earnings. The king of the mushroom industry was the owner with the most toys," Pennsylvania State Policeman Tom Cloud said.

Fellow trooper J. R. Campbell added, "They tried to outdo each other. Guys made a lot of money a year and they spent it. The Campbell soup company purchased a lot of mushrooms and their prices dictated the industry margins. A couple of pennies in the purchase price made a lot of difference in the profits. The greed was tremendous."

A prominent mushroom grower was Guido Frezzo, one of

the owners of Frezzo Brothers, Inc., a mushroom growing and composting company in Avondale, Chester County, not too far from Kennett Square. Frezzo liked the niceties of life, including oriental rugs, fine firearms and Wyeth paintings. One Chadds Ford resident called Frezzo the godfather of the time.

Frezzo knew the Wyeths and dropped off fresh mushrooms to Andrew and Betsy. Frezzo also took an early interest in drawings by Jimmy Lynch, Jamie's boyhood friend. Frezzo purchased Lynch drawings and then sold the drawings to the Franklin Mint where they were used on Christmas cards.

Besides the Chadds Ford artists, Frezzo had another associate, Benny LaCorte, the teacher, barber, chiropractor and thief. "Benny and Frezzo were good friends," FBI agent Richter said. Frezzo helped LaCorte become a chiropractor by loaning LaCorte $40,000 for his schooling and $60,000 to setup his office.

Cloud believes the relationship between Frezzo and LaCorte was cemented through a private card club. The card club and the mushroom industry were controlled by the Italian descendants living in the Kennett Square area. "The card club was near Benny's (LaCorte) barbershop. Benny's dad was involved in the club and I'm sure Frezzo was also. This is a small community."

Assistant U. S. Attorney Batty said Frezzo had established a pattern of buying stolen property from both LaCorte and Franny. Batty, who prosecuted Frezzo in federal court, said Frezzo purchased a diamond ring for $1,000 that was stolen from Dorothy Theodore, owner of the Chadds Ford Inn, who was dying of cancer at the time of the theft. Another large diamond ring stolen from another residence also was purchased by Frezzo.

Diamond rings weren't the only items Frezzo acquired. Batty said Frezzo purchased, from Franny, an antique Kentucky rifle stolen in Chadds Ford, a truckload of tires, between 150 and 200 guns and 15 stolen Oriental rugs. One of the rugs, Persian, was valued at $35,000.

Frezzo made another deal with LaCorte and Franny. Frezzo purchased three of the stolen Wyeth paintings. In return for the three

works of art, Frezzo gave Franny a 1957 Chevrolet and $2,000. The car's value was about $5,500. LaCorte delivered the paintings to Frezzo at the mushroom man's office and placed them in the building's attic. LaCorte remembered receiving about $1,500 for his part in the theft.

LaCorte wasn't through selling those same three Wyeth paintings. After another Chester County criminal, Doug Fuller, told LaCorte he was willing to pay $3,000 for each of the paintings that Frezzo possessed, LaCorte went back to Frezzo's office attic and stole back the paintings. Frezzo was unaware the paintings were missing until September 1982. When the theft was discovered, Frezzo blamed Franny and not his good friend LaCorte.

The valuable stolen artwork went from the attic of a mushroom grower to being buried in plastic garbage bags in a field near LaCorte's home. Fuller immediately purchased one of the three paintings for $2,700 and LaCorte put the remaining two paintings into the garbage bags and in the ground to await Fuller's final purchase. Fuller at first didn't respond to LaCorte's calls about the remaining paintings. Finally, Fuller called LaCorte and offered $1,700 for the remaining paintings and a deal was struck. The paintings were retrieved by a gambler, John Sorber, known as Sadsbury John. According to court records, Fuller sold one of the paintings to Sorber and then a second one to Sorber for a total of $3,000. Fuller received $2,500 in cash and $500 was credited to a gambling debt.

* * *

After Frezzo was linked to the theft of the Wyeth paintings and arrested, he contended he was just misunderstood and was attempting to recover the works of arts to restore them to the Wyeths. Frezzo told a member of the federal probation office that he indeed had purchased the paintings from LaCorte, but only to impress his friends, including Jimmy Lynch. He said he planned to return the paintings to the Wyeths to "put himself in a good light" with them.

Batty wasn't buying Frezzo's story. Batty said Freezo's attempt to make himself appear misguided but basically honest was clumsy and an obvious attempt to deceive the sentencing judge. None of Frezzo's actions backed up his claims of honorable intentions, according to Batty. Batty pointed out Frezzo had the paintings in his possession for months and never once attempted to return the stolen paintings. During Frezzo's federal trial, three of the defendant's character witnesses, who were called to the stand by the defense to show what an honorable guy Frezzo was, had been convicted themselves of receiving stolen property from the murderous Johnston gang.

Frezzo had a conversation with Mary Landa, The Andrew and Betsy Wyeth Collection Manager, near the end of July 1982, that also belied his intention to return the paintings to the Wyeths. While being interviewed by Richter, Landa repeated a conversation she had with Frezzo. Frezzo, Landa said, appeared at the Chadds Ford Publication Company where she worked and requested that a reproduction of Andrew's 1956 painting *Roasted Chestnut* be framed. Frezzo then asked Landa about the statute of limitations on prosecuting those involved in the theft of the Wyeth paintings. At the time Landa was reading a book about stolen artwork in Germany and told Frezzo that she believed thieves could be prosecuted for up to 40 years after the crime, but she wasn't sure. Frezzo commented 40 years was a long time and the pair talked about some of the artwork the Nazis stole during World War II. Then Frezzo asked Landa if she knew any attorneys she could ask to verify the length of time a crime could be prosecuted. Also, Frezzo asked her to not let the Wyeths know he asked the question. LaCorte was with Frezzo when the conversation took place. Landa asked Frezzo why he asked such a crazy question. Neither Frezzo nor LaCorte responded. Landa never researched the statute of limitations for Frezzo.

Details of legitimate purchases by Frezzo from the Wyeths were supplied to the FBI by Betsy. On Valentine's Day in 1982 Frezzo picked up framed reproductions and purchased two additional

copies of *Reefer* for $3,000 plus he wrote a check for $50 to frame a copy of *Roasted Chestnuts*. On December 2, 1982, he paid $310 for the framing of the copies of *Reefer*. Also, Betsy reported that on the day before Christmas one year, Lloyd List, a Frezzo associate, appeared at the Wyeth estate with wine and mushrooms that Frezzo asked to be delivered to the Wyeths.

* * *

With two members of the Matherly family, Robbie and his father Noel, cooperating with law enforcement, the time was right for Richter and Cloud to visit Franny Matherly. Noel was in the process of negotiating with federal prosecutors for a plea bargain for his part in various thefts. On July 29, 1982, a plea agreement was reached with federal prosecutors calling for 10 years imprisonment to be concurrent with any state sentences Noel might receive. Noel agreed to testify against members of his family. Noel was represented by attorney Robert Donatoni. The plea agreement was signed for the prosecutors by Batty and U. S. Attorney Peter F. Vaira.

On May 10, 1982, Cloud and Richter paid a visit to Franny's home. Franny wasn't surprised by the visit as he knew he was under suspicion after reading newspaper articles. The forewarning gave Franny time to craft his answers to Cloud and Richter. The law enforcement officers could tell Franny wasn't being entirely truthful with them. Franny's wife Nancy attempted to get her husband to be honest with Cloud and Richter but was unsuccessful.

At one point during the interview Franny asked if there was a reward offered for the return of the paintings. Cloud asked Franny, the fence, "How much would it cost to get the paintings back?" Franny replied $50,000.

Franny was desperately attempting to put distance between himself and the stolen paintings. Franny approached his sister, Janet Pugh, and asked her to keep some items for him. Franny never told Pugh that the items were three of the stolen paintings.

Since Pugh wasn't on the police's radar at that moment, Franny felt the paintings would be safe. Franny knew the police were keeping a close eye on him and another sister, Ruth Madron.

After the arrest of his brother Noel, Franny called Porter on May 10, 1982, and asked him to make a return trip to Pennsylvania to take away the stolen artwork. Almost immediately Porter responded. On May 16, Porter and Porter's brother-in-law Glen Barnett began their trip to Pennsylvania. The two men met Franny at a notorious bar, the Wooden Shoe, outside of Kennett Square. The bar had its share of fights and criminal clientele during its existence. The meeting didn't last long. Porter was driving an AMC car and as Porter approached Franny, Barnett opened the hatch in the back of their car. Three paintings were wrapped in Glad plastic trash bags. After the transfer of the paintings to the AMC, Porter and Barnett headed back to Tennessee.

Two days after Franny called Porter, Robbie Matherly testified before the federal grand jury in Philadelphia. Robbie placed on the record what he knew of the criminal doings of the Matherly/Madron family gang, sometimes known as the M & M gang. The investigation of the Wyeth case was intensifying, and information was being obtained that the criminals had Tennessee connections. On September 29 Robbie made another appearance before the grand jury giving additional details.

Franny was taken into custody on July 28. Franny had two previous convictions for receiving stolen property and interstate transportation of stolen goods. Franny's arrest information included that he was born in Concordville, outside of Philadelphia, and that he had three brothers, Noel, Larry and Dean and four sisters, Ruth Madron, Janet Pugh, Shirley Matherly and Linda Styke. He reported he received his GED diploma while serving in the U. S. Army. At one point Franny's wife, Nancy went to mushroom owner Frezzo in an attempt to obtain money for bail and her husband's attorney. At first Frezzo refused. Frezzo blamed Matherly for stealing back the stolen paintings he had purchased from LaCorte.

William Porter wasn't known to Richter before the Wyeth case began but some of the state policemen had at least heard Porter's name. Law enforcement would soon become very familiar with him. Porter was paid a visit by FBI agents Lanny Smith and Robert Morrison in Johnson City, Tennessee, on August 11, 1982. The agents met Porter at his business, Home Owners Security Company where had had three employees working for him full time and a part-time worker named Speedy Gonzales. Porter admitted knowing Franny, but he claimed he had lost contact with Franny about a year before the interview. Porter claimed he had been outside of Tennessee only twice recently, one time to Philadelphia and one time to Maryland. He told the FBI agents they could check with his probation officer as he had to report the trips out of state. Porter said he was on probation on six burglary convictions. Porter denied taking part in the Wyeth theft.

FBI agent Stephen Buttolph met a Matherly family member, Dean Matherly, at a McDonald's restaurant on Volunteer Parkway in Bristol, Tennessee, a week after Porter was interviewed. Dean said he was born in Butler, Tennessee, but had lived in Bristol for 20 years and was working as an insurance salesman in Bristol. Dean said he knew Porter and had seen Robbie only on a few occasions. Dean said he knew of the hospitalization of Robbie because his sister-in-law, Nancy, told him about the fight Robbie had with his brother, Noel. Dean also acknowledged that he knew Robbie was cooperating with police but denied ever knowingly receiving stolen property from family members.

Back in Pennsylvania the law enforcement team continued to gather information on the Chester County crime family. During one interview Richter was told by Robbie that Robbie's uncle Dean certainly knew that items he secured were stolen by family members. Later in August, Richter interviewed Gerald Madron, known as Whitey. During the meeting Whitey admitted taking part in burglaries in Delaware and Pennsylvania.

Franny, the expert at selling stolen goods, was sitting in Chester County prison in August 1982. Richter set up a meeting

with Matherly's wife, Nancy, at the West Chester Inn. During the meeting Nancy wanted to know what testimony federal prosecutors wanted from her husband. Nancy promised Richter that she would try to obtain her husband's cooperation on her next visit to Chester County prison to see Franny. Nancy did have a major concern: she was afraid she and her son would be in danger if Franny cooperated. Gang members didn't take too kindly to snitches. Many of the murders committed by the Johnston brothers were because of gang members helping law enforcement.

Obtaining cooperation by a member of the Matherly family was critical to the investigation's success, according to Assistant U. S. Attorney Walter Batty. "Noel was confronted immediately and then Franny and then Nancy. Nancy was smart and Dave (Richter) had credibility with her from an earlier case."

Richter added, "Franny didn't cooperate until Nancy convinced him. We interviewed everyone."

I remember recordings were made early on and Nancy made some with Frezzo," Batty said. "Nancy cooperated early in the investigation. I'm not sure if the recordings were productive but they confirmed a relationship between Franny and Frezzo.

"The dominos began to fall."

* * *

As the pressure mounted on LaCorte, the thief attempted to retrieve the paintings and return them to the Wyeths. LaCorte was able to secure a letter signed by the Wyeths to allow the transportation of the stolen paintings without fear of prosecution if the person was in the process of returning the artworks. LaCorte used an intermediary, Jimmy Lynch, the boyhood friend of Jamie Wyeth. LaCorte believed Betsy had agreed to take care of him at Christmas if the paintings were returned.

On November 15, 1982, Lynch visited Betsy and asked for the letter. Lynch said he was told that the paintings would be returned by November 19, 1982. Lynch indicated the person seeking the

letter was known as Jingle Bells. LaCorte believed the Wyeths would know the Jingle Bells reference referred to him. Betsy wasn't sure if she should author such a letter and called Richter. Richter conferred with Batty and Riley and the go-ahead was given at 7:30 p.m. that evening.

The letter said, "To Whom it may concern, We, Betsy James Wyeth and Andrew Wyeth, certify that the person in possession of these paintings is attempting to insure the safe return of same to us by midnight, Friday, Nov. 19, 1982." The letter was signed by Betsy and Andrew.

Lynch finally told Betsy that LaCorte was the person who wanted the letter. LaCorte was extremely upset over the theft and didn't want to be caught with the paintings, Betsy was told. LaCorte claimed the original buyer had backed out of a deal because of the heat being applied by law enforcement. The buyer LaCorte referenced was the mushroom man, Guido Frezzo. Frezzo wanted original Wyeth paintings to go with his prints. When Betsy relayed Lynch's conversation to Richter, she said she expected to receive a phone call before November 19. She had been told that call would include instructions on where to find the paintings.

The expected phone call never materialized. The afternoon of Saturday, November 20, Lynch again visited Betsy at her home. Lynch said he had just visited LaCorte, who was sick in bed with the flu. LaCorte was sorry he disappointed Betsy by not being able to obtain the stolen works of art. LaCorte promised, through Lynch, to return the paintings but it might take until Christmas. LaCorte had one favor of Betsy, LaCorte didn't want Betsy to alert the FBI to his efforts. LaCorte claimed he was not involved in the theft.

LaCorte was working hard to obtain the paintings. He discovered through gambler John Sorber that another criminal, Vincent Perry, was looking to gather the stolen collection. Perry, LaCorte believed, was willing to pay a lot of money for the Wyeth paintings. In late November LaCorte contacted Porter, saying he wanted to retrieve the paintings from Tennessee.

A meeting was set with Porter and LaCorte flew to Johnson City, Tennessee, and rented a car. He met Porter at a Pizza Hut in the city. In the parking lot the two men swapped cars and Porter drove away with LaCorte waiting at the Pizza Hut. Porter returned and told LaCorte that his rented car now contained all of the remaining stolen paintings. LaCorte checked to make sure the artwork was in the car before driving to Pennsylvania.

Late in the evening of November 23 or early in the morning of November 24, LaCorte arrived in Coatesville and went to the home of gambler Douglas Fuller. A fairly new four-door, dark-brown Cadillac was secured, and the paintings were placed in the car.

The Wyeths indicated they would pay $75,000 for the paintings. Betsy said no money would be exchanged until verification that the artworks were the actual paintings and they were in good condition. The Wyeths were also eager to obtain the remaining paintings and the quilt that was taken in the burglary.

* * *

The time had come for Cloud and Richter to visit LaCorte. The law enforcement pair took Franny along with them on December 7, 1982. "When Benny saw Franny, he knew the jig was up," Cloud said.

Richter remembers LaCorte standing in his kitchen by a sink eating when they arrived. "Benny had a meatball on a fork when he looked up and saw us," Richter said. "Later Benny told me that both the fork and meatball flew from his hand and he never saw either one again."

LaCorte also recalls the visit. He had just entered his kitchen after spending time in his home office. "I looked out my front window and everything just broke loose," LaCorte said. "The FBI and state police swarmed into my home. And there was Francis Matherly with them." LaCorte also recalled a conversation he had with Franny after Franny was arrested. LaCorte said he

told Franny he wouldn't blame him if Franny told police about the burglaries. LaCorte only asked for notice of 48 hours so he could flee. Franny said, "It'll be a cold day in hell before I tell on anybody." The temperature on December 7, 1982, in Chester County or hell was not noted.

LaCorte was feeling the pressure from law enforcement. At one point he made plans to escape to Rio de Janeiro, Brazil. He secured a passport and received immunizations. LaCorte had little money and his marriage to his wife Patricia was in trouble. His dream about escape to an exotic locale wasn't possible. The only viable option LaCorte had available to him was cooperating with law enforcement.

"Benny decided he would tell us the truth," Richter said. "For the most part he laid out, in the best details he could, the way the Wyeth theft took place. There were some errors but mainly his information was accurate. Benny had had enough of the life of crime. Benny said his motivation was obtaining extra money. He said he was sorry for his criminal activity."

In a letter LaCorte wrote to *Daily Local News* reporter Bruce Mowday in 1985, LaCorte said he was in only four burglaries with Franny and Porter. They were the Theodore, Avello, Wyeth and Fortuno thefts. "I wasn't involved in the arson case or the 100 plus thefts Franny and Porter were involved in," LaCorte wrote.

With LaCorte's assistance the first of the stolen Wyeth paintings was recovered that night, less than nine months after the theft. LaCorte took FBI agents Richter and Frank Kenney to see Doug Fuller.

Earlier in the year Fuller was working at Jones Automotive in Coatesville, Pennsylvania, when LaCorte and Franny appeared to ask a favor. They wanted Fuller to store some artwork for them that was in the trunk of LaCorte's vehicle. Fuller agreed. LaCorte and Fuller switched cars for the day. After work Fuller drove to his nearby home on West Lincoln Highway and placed four bundles in the attic of the home he was sharing with his girlfriend, Rebeca Reese. Later Reese told Richter and Kenney she recalled being

awaken by Fuller. Fuller was ripping up the floor boards of the attic. Reese inquired about Fuller's actions and Fuller said he was hiding paintings. Reese said she never saw the artwork.

Fuller kept all four paintings until LaCorte and Franny took back three of them. The retrieved paintings ended up in Janet Pugh's home. For storing the stolen items, Fuller was given a painting. He believed it was either Andrew's painting *Block and Tackle* or *Charlie Stone's Fish House.*

Fuller at the time owed a $1,200 gambling debt to Sadsbury John Sorber. The two men, obviously not art experts, placed the value of the painting at $3,000 and a deal was struck. Fuller said he eventually gambled and lost the remaining $1,800 back to Sorber. Sorber tried to sell all of the paintings for Franny and LaCorte but couldn't find a buyer. Soon after Sorber purchased two other paintings from LaCorte.

Several weeks before the visit by Richter and Kenney, Fuller said LaCorte called him looking for the painting *Writing Chair.* LaCorte said he had a buyer willing to spend $10,000 on the painting. That buyer, according to LaCorte, was in trouble with the law and had made a deal with law enforcement to retrieve all of the stolen paintings and leave them at a hotel where the FBI would find them. In exchange no criminal charges would be filed against the man, Vincent Perry, known as the Meat Man. Indeed, Perry would become a key player in the attempt to recover the paintings, but Perry never had such a deal with federal prosecutors.

During the visit by Richter and Kenney, Fuller admitted he had access to one of the two stolen pencil sketches done of Rudolph Nureyev by Jamie Wyeth. The painting was in his attic and the FBI agents took possession about 10:00 p.m. on December 7. Richter took the painting to his home for the night. "I called Betsy and she was thrilled," Richter said.

Fuller, the criminal surrendering the first stolen painting, didn't survive to see the end of the Wyeth case. A gambler, Fuller had convictions for conspiracy, perjury and driving while under the

influence. The father of three, two daughters and a son, committed suicide on April 29, 1983.

"When Fuller committed suicide, doors to prosecution of other crimes were closed to us," Richter said. "I think Fuller was under a lot of pressure and didn't see any other way out. Before his death he did supply a lot of information on the theft of platinum from the Johnson Matthey company. Fuller was involved in several crimes over the years. While he was out on bail, he got a gun and killed himself."

At least one person isn't so sure Fuller died at his own hand. Restaurant owner George Malle of Downingtown said the timing of the disappearance of a Fuller's girlfriend just months after the reported suicide convinced him Fuller faked his death. Fuller lived in Florida or some other location and spent years laughing at everyone he left behind in Chester County, according to Malle.

· 7 ·

The Meat Man and Joe Cadillac

Vincent Perry and his Claymont, Delaware, criminal cohort Joseph Landmesser, known as Joe Cadillac, were in big trouble with the United States Department of Justice as Christmas 1982 approached. They were charged with running a sports betting ring. The criminal pair was seeking a way to avoid prison time and thought if they could return the stolen Wyeth art, they could bargain their way out of a federal penitentiary.

Perry, a known gambler who lived in West Chester, was called the Meat Man because he ran the Summit Beef Company in Linwood, Delaware County, Pennsylvania, and Taylor Pet Food in Downingtown, Chester County, Pennsylvania. The businesses weren't quite legitimate, as Perry was charged by the federal government for selling filthy and putrid pet food to a meat processor for sale to state hospitals, schools and military bases. The beef eventually was sold to three Delaware school districts and the Dover Air Force Base along with other institutions in Pennsylvania, New Jersey and Arkansas.

In the summer of 1982 Sadsbury John Sorber told Perry that the Wyeth paintings were for sale for far under the paintings' values. Sorber said he obtained one painting from a man, Doug

Fuller, who owed a gambling debt. Sorber said he could obtain a Wyeth for Perry. The Meat Man resisted several of Sorber's offers but eventually struck a deal. Perry paid $30,000 for what he later believed to be Andrew's *Gray Mare*. When talking to federal agents, Perry wasn't exactly sure which Wyeth painting was first purchased.

Perry told Sorber he would pay half the money before the painting was delivered and the other half when he received the artwork. Sorber transferred the painting to one of Perry's employees at Keystone Racetrack in Bensalem, Pennsylvania. Perry placed the artwork in a storage area behind a wall in his office.

Later in the summer Sorber told Perry three additional paintings by Andrew were available for $25,000. They were *Block and Tackle*, *Charlie Stone's Fish House* and *Thawing*. At first Perry declined the offer but eventually paid the money and stored the paintings in a home of a friend. Perry believed the transaction with Sorber took place about Labor Day. A week later the paintings were wrapped in green trash bags and moved to James Smith's home in Delaware. Smith, a retired postal worker, lived on Naaman's Road outside of Wilmington, Delaware, and worked for Perry.

As the FBI closed in on Perry and Landmesser, Landmesser believed they could receive a break on the gambling charges if they could obtain and return all the missing Wyeth paintings. Landmesser had a preliminary conversation with FBI agent Carl Wallace on the subject.

"I knew about the Wyeth case and that Dave (FBI agent Richter) was investigating," Wallace said. "Everyone assumed the criminals didn't have a good contact for the expensive art. I had a wiretap on Joe Cadillac. At the time Joe Cadillac and Perry were charged with transporting gambling material across state lines. This was not a major case. We were hoping they would plead out and give us information on other cases. I knew Perry was selling drugs and the mafia was shaking him down in connection with his bookmaking operation."

Perry's bookmaking operation operated in Pennsylvania, Delaware, Florida, Nevada and New Jersey.

"Joe Cadillac was a gambler and not a bookie," Wallace said. "He would make a buck any way he could. Landmesser recruited guys to go to banks and take out fraudulent loans. They had no intention of repaying the loans. Landmesser would get a cut of the loan. We also suspected Landmesser had connections with harness drivers and fixed races, but no charges were ever filed. Joe Cadillac never wanted to work. When we were investigating he lived in Wallingford with his parents.

"I told Joe we could work things out if he pleaded and gave us some information on other crimes. Perry was a hard ass but not Joe. I told him we are looking for the Wyeth paintings. I had no inkling he knew anything about the paintings and Joe played dumb."

* * *

Perry and Joe Cadillac weren't the only criminals trying to make a deal for the paintings. Bookie Donald A. Rice of Newark, Delaware, later admitted to FBI agents that he had tried to sell the stolen Wyeth paintings to a Bob Boyer, who was in fact FBI agent Bob Bazin. Rice said he knew he was dealing with an FBI agent and that his telephone conversations were being taped.

Rice claimed he never saw the Wyeth paintings and was told of their existence by two men. Rice said Ed Swan, who was in the gold business and traveled internationally, and another man who was a pimp from Chester, Pennsylvania, told him about the artwork. Swan and the pimp said their source was a man named Vince, believed to be Perry. Rice remembered meeting Vince once at a Monte Carlo night at the Home Plate Bar in Chester. He especially remembered the "very pretty" blonde with Vince.

Rice was subpoenaed to appear before the federal grand jury.

* * *

In September or October of 1982, Perry wasn't sure of the exact date, Sorber told Perry all of the remaining paintings were still available for a price. Sorber did caution that the paintings weren't immediately available as they weren't in Pennsylvania but were "down south." Perry told Sorber about a possible pending deal with the FBI on the gambling charges and Sorber agreed to see if he could obtain the paintings for Perry. Sorber wanted $60,000 for the paintings with $20,000 as a down payment.

The criminal pair, The Meat Man and Joe Cadillac, then contacted the FBI and negotiations began in earnest for the return of the paintings in exchange for lesser prison sentences. Perry was to receive three months and Landmesser six months in prison. Assistant U. S. Attorney Jack Riley remembers Perry playing the primary role in the negotiations for the criminal duo. Perry told prosecutors he didn't want to make any money on the deal. Indeed, Perry did not as he admitted paying out $117,500 to Sorber. The total cash outlay by Perry was $112,500 as Sorber owed him a $5,000 gambling debt. Perry wasn't as altruistic as he appeared. Later, Perry admitted he wanted the FBI to reimburse him $75,000 and he wanted to hold back three of the paintings until Andrew died or the heat from the case died down and he could sell them. Perry then planned to sell the three paintings for $25,000, thus making his loss only $17,500.

The $75,000 would come from the Wyeths. The Wyeths indicated they were willing to pay if the paintings were all returned in good condition. Perry obtained the $20,000 front money for Sorber and LaCorte then went to Tennessee to retrieve the remaining paintings from Porter. Sorber turned over the paintings to Perry, who then possessed 14 of the 15 stolen paintings. The paintings were taken to Smith for safekeeping. To prove that the paintings were in good condition, Perry instructed Smith to make two sets of photographs of the paintings.

Perry and Landmesser met with Richter on a Saturday morning to turn over the photographs. One of the photographs revealed

that one of the paintings had slight damage. Perry pushed the FBI to complete the deal. Perry wanted his $75,000. The money would come in handy as he was about to travel to Florida with his wife Georgie. In an effort to pressure the federal government into making the deal, Perry told law enforcement the Wyeth paintings would be sent outside the United States unless he received his money.

The U. S. Attorney's office had little interest in the offer made by Perry and Landmesser. Assistant U. S. Attorney Terry Batty approached his boss, U. S. Attorney Peter F. Vaira, with the details of Perry's proposed transaction. "Peter was not interested in dealing with them," Batty recalled. "I thought Peter made the correct call. We had to grind out the prosecutions in the old-fashioned way of good police work rather than to rely on individuals who could be total frauds. The Wyeth case was a complicated investigation. Peter had great instincts. Investigative and prosecutorial decisions were being made every day of the week on the case."

FBI agent Mike Leyden believed a court ruling prohibited the government from purchasing stolen goods from criminals.

"We all agreed Perry and Landmesser could pound sand as far as their proposal was concerned," Riley said. "If they wished to take action on their own to benefit themselves, that was fine, but they had to do so themselves. They would not escape prosecution. We weren't dealing, and we didn't play games."

Batty delivered the message to Landmesser and Landmesser called Perry who was in Florida. Perry's first thought was to keep the paintings and try to sell them back to the Wyeths. After Perry discovered the FBI knew he had possession of all of the remaining paintings, Perry was advised by his attorney, Carmen Belfonte, to surrender the paintings and make the best deal possible with the government. On December 17, 1982, Perry entered into a plea bargain and pleaded guilty to conspiracy and interstate transportation of wagering information. Because of his cooperation in the Wyeth case, Perry was sentenced to serve 30 days in a work-release program.

* * *

Perry's gambling charges would soon become the least of his criminal worries. Just two months after returning the Wyeth paintings, Perry ordered the murder of a federal informant. Perry, Louis Summa and Charles Kevin Kelly, a Pagan motorcycle gang leader, were charged with murdering 22-year-old Christopher Walker of Linwood, Pennsylvania.

Walker was scheduled to testify in a methamphetamine case against Perry but disappeared two weeks before he was to take the witness stand. "Perry was a vicious guy," FBI agent Wallace said. Walker had secretly recorded two drug transactions with Perry in February 1983 as part of a DEA investigation, according to Wallace. "DEA gave Walker money for the drugs and a recorder. After the purchases we put Walker in an apartment just beyond the Commodore Barry Bridge in New Jersey and told him to stay put. We brought him food, movies and other items he wanted. But he longed to be back at his Chester area home and left our protection." The bridge spanned the Delaware River and connected Chester, Pennsylvania, with Bridgeport, New Jersey.

Perry and his crew found Walker in Chester and offered the police informant a deal. Summa escorted Walker to a Hilton Hotel at Claymont, Delaware, off Route I-95 outside of Philadelphia. In exchange for signing a document exonerating Perry of the criminal charges, Walker was offered $50,000 and a plane ticket to Detroit. If Walker didn't testify, the drug case would be dismissed against Perry. Walker agreed but Perry had no intention of keeping the deal with Walker.

Summa drove Walker to an isolated farm near the Christiana Mall in Delaware. Waiting for them were Kelly and John Hall. Kelly shot Walker multiple times. One witness reported Kelly fired nine shots and had stopped to reload the pistol at one point. The criminals had pre-dug a grave and buried him. Wallace said the murderers wanted to pour lye over the body to destroy evidence but had purchased lime instead. The lime preserved Wallace's corpse.

Two years after the police informant was killed, Hall, a convicted drug dealer and violator of gun laws, began cooperating with law enforcement. Hall led police to the shallow, lime-filled grave where Walker's remains were found. Wallace recalled the day Walker's body was discovered. The FBI agent had tickets to a Philadelphia Phillies professional baseball game. He didn't have time to change clothes before the Phillies game and the pungent death smell from the grave was on the agent as he attended the game. "They made me sit alone," Wallace said of his friends at the game.

The murder case was solved after Summa and Hall began cooperating. Hall and Summa initially were charged as participants in the killing but were given immunity in exchange for their testimony. They revealed that the gun used in the killing was turned over to other criminals at the Four Winds bar outside of West Chester and then dumped in the Delaware River. A search of the river was made where the gun was reportedly tossed but the weapon wasn't found.

Perry and Kelly were convicted of first-degree murder in Walker's death after a six-week trial, beginning in September 1986. They were sentenced to life imprisonment. Perry's sentence for selling 385 pounds of putrid meat added an additional two years in prison. When Perry sold the meat, he claimed it was inspected hamburger and stewing meat. When he was arrested on murder charges, Kelly, who lived in Boothwyn, Pennsylvania, was in prison serving time for the rape of an Elkton, Maryland, woman.

"Perry believed he could beat the drug case with the murder of the informant," Riley said. "He didn't. Perry was convicted of the murder and died of cancer while in prison."

* * *

Perry took attorney Carmen Belfonte's advice about returning the stolen Wyeth artwork. James Smith was contacted and told to take all the paintings in his possession, wipe them clean and be ready to load all of them into Perry's Cadillac.

On December 20, 1982, at about 4:45 p.m. The Meat Man and Joe Cadillac walked into the FBI office in Newtown Square with attorney Belfonte. In Perry's late model Cadillac were the remaining 14 missing paintings. The paintings were unloaded and surrendered to the FBI. Richter and Perry signed a receipt recording the return of the paintings. Perry said he considered his action to be the Wyeths' Christmas gift for 1982.

Richter contacted Betsy to notify her of the recovery. "I recall the exact time the FBI called to inform me the paintings were recovered, it was 4:50 p.m.," Betsy said. "Andy and Jamie were shopping in Philadelphia. Andy, Jamie and I went to Newtown Square."

A celebration was held at the FBI office in Newtown Square that evening. About 40 people attended, including law enforcement members, family and friends. Two cases of top-shelf champagne were brought to the event along with excellent food. Andrew signed prints of his paintings the *Writing Chair* and gave them to the law enforcement people who helped investigate the case.

One of the law enforcement officers receiving a print was Chester County Chief County Detective Charles Zagorskie. Zagorskie recalled stopping Andrew for speeding in the 1960s. "He was driving this old car. I wasn't sure if it would go fast enough to speed but it did. When I stopped him, he told me he was Andy Wyeth the painter. His name didn't mean anything to me. I almost asked him if he knew my relative who painted houses in Scranton." Andrew signed Zagorskie's print by saying he hoped Zagorskie would remember him if he ever pulled him over for speeding again.

Andrew told the law enforcement investigators he held no grudges against the burglars. "There's too much hate in the world as it is."

Betsy wanted to call President Ronald Reagan and tell him of the recovery, according to Richter. "Betsy wanted Reagan to announce to America that the country has received a wonderful

Christmas gift, the return of the paintings." The law enforcement team talked Betsy out of making the call to President Reagan as the case wasn't completed. An important element was missing.

"We didn't have Porter in custody," Richter said.

The next day, December 21, 1982, Andrew and Betsy Wyeth regained possession of the paintings stolen the previous March from their Chadds Ford home. Betsy commented the criminals took better care of the paintings than some museums as the paintings appeared to be in as good or better condition than some returned after a loan to a museum. One painting had a crease and another had slight damage to the frame.

'THAT'S THE MAN' who recovered the paintings, Betsy Wyeth says of FBI agent David Richter dur- ing yesterday's press conference in Newtown Square. Staff photos by Bill Stoneback

'It's a miracle,' says Mrs. Wyeth of recovered art

By BRUCE MOWDAY
(Of the Local News Staff)

"I can't look at them enough. It's a miracle," Betsy Wyeth said of her recovered stolen art work as she entered the FBI office in Newtown Square yesterday to attend a press conference.

"This man did it," Mrs. Wyeth said as she spotted FBI agent David Richter. Richter was credited for solving the crime yesterday by U.S. Attorney Peter F. Vaira and John L. Hogan, special agent in charge of the FBI's Philadelphia office.

Mrs. Wyeth was accompanied by her artist husband, Andrew. They both praised the work of federal and state law enforcement officials. The stolen art work — 15 paintings by Wyeth, his son Jamie and two other

artists worth more than $700,000 — was displayed yesterday.

Five persons, including four who reside in Chester County and a Tennessee man born in West Chester, were indicted by a federal grand jury Wednesday for planning the March 27 heist and fencing the stolen paintings.

GUIDO FREZZO, 51, of Rt. 41, Avondale; Douglas Fuller, 36, of W. Chestnut Street, Coatesville, Benedict LaCorte, 48, of Rt. 41, Chatham; William Porter, 36, of Old Stage Road, Jonesboro, Tenn.; and John Sorber, 46, of Parkesburg were indicted. Frezzo is the owner of Frezzo Brothers Inc. mushroom business.

Mrs. Wyeth said she didn't know the persons accused of the crime, but one law enforcement official said the

(Continued on Page 2 Column 1)

Daily Local News of West Chester, PA, Friday, January 28, 1983

·8·

MASTER BURGLAR

The safe return of the 15 pieces of art stolen from the Wyeth estate constituted only the first phase of the investigation for law enforcement. The prime suspect, master burglar William Porter, remained free. Porter, who took part in more than 1,500 burglaries during his criminal career, was free, armed and considered dangerous. One of his fellow burglars, Benny LaCorte, considered Porter to be one of finest burglars in the world.

Late in 1982 and early in 1983 police continued to gather information on Porter, his cohorts and his crimes. Robbie Matherly, the young criminal beaten by his father, was the first crook to mention Porter but Robbie knew little about the master cat burglar. On December 14, 1982, just a week before the paintings were recovered, LaCorte talked with Richter at his FBI office in Newtown Square about Porter. LaCorte was one of Porter's criminal accomplices.

LaCorte, the chiropractor, barber and teacher, admitted being involved in fencing stolen goods for more than two decades. While his life of crime began in 1960, LaCorte said he didn't continuously commit criminal acts. He restarted his life as a burglar in 1982 with his friends Franny Matherly and Porter. LaCorte

told Richter about some of his crimes. The Wyeth case would be the key to solving hundreds of other criminal cases in Pennsylvania, Delaware and Maryland.

Hank's Place is a popular restaurant in Chadds Ford. On weekends patrons expect a long wait before being seated. Andrew and Betsy frequented the diner and many afternoons Andrew sat quietly eating his lunch in solitude. The owner of Hank's Place in the 1980s, Henry Shupa, was the victim of one of the burglaries committed by Franny and Porter. LaCorte said Franny and Porter believed Shupa kept proceeds from the restaurant in his home. LaCorte told Richer he tried to stop the crime. LaCorte begged his fellow criminals not to commit the burglary because he had known Shupa all his life and Shupa's wife was a chiropractic patient. LaCorte also claimed he was against committing the Wyeth burglary. LaCorte said Franny told him the Shupa burglary didn't yield any stolen goods.

LaCorte gave police a mountain of information on crimes and criminal cohorts once he agreed to cooperate. Guido Frezzo, the mushroom grower who helped LaCorte set up his chiropractic practice and purchased stolen Wyeth paintings from him, was another subject during the conversation with Richter. Frezzo purchased between 150 and 200 guns from Franny in a space of a couple years, according to LaCorte.

During one court session, LaCorte testified he would have lied for Frezzo to keep the mushroom grower out of prison if Frezzo hadn't played the "big shot." LaCorte said, "I didn't want to see him go to jail. I wanted to save the man. Do you think we enjoy putting people in jail?"

LaCorte wasn't the only criminal informing on his criminal buddies. Franny, the criminal who promised LaCorte that hell would freeze over before he talked to police, was giving up information on Porter. In a January 1983 meeting with Richter, Franny disclosed facts concerning a burglary that he committed with Porter in 1981. Porter and Franny stole a car, later abandoned at a bar in Thorndale, Pennsylvania, and entered a home in Centerville, Delaware,

near a popular restaurant, Buckley's Tavern. They took 15 oriental rugs from the home and took them to Franny's residence. The next day LaCorte and Frezzo visited Franny and Frezzo purchased the rugs for $2,500. Frezzo kept some of the rugs for his personal use and allowed LaCorte to sell the rest of them.

Franny admitted to additional crimes with Porter during a meeting with FBI agents

James Feehery and John Stoddard Jr. and Pennsylvania State Policeman Bob Martz in December. Matherly said he had known Porter since childhood and caught up with Porter in later life when he saw Porter at Ruth Madron's home. Madron is Franny's sister. Franny told the law enforcement officers he acted as the getaway driver during burglaries at the homes of Hercules Avello, Dorothy Theodore and Fred Fortuna. LaCorte admitted being involved in some of the crimes as he conducted surveillance of the intended victims' homes

Avello was in the mushroom business and the criminals believed he kept money from his business and jewelry at his home. An Avondale contractor told Franny about the jewelry. Franny commented he would "bring his boys up from Tennessee." The boys were going to meet at the Kennett Square Birch Inn Bar.

On February 5, 1982, just weeks before the Wyeth heist, Franny called LaCorte to meet him at the Birch Inn between 4:30 p.m. and 5:00 p.m. LaCorte did as instructed and Franny arrived with Porter in his car. A white panel truck with Tennessee plates then drove into the parking lot. The criminals drove to the Avello residence where the three Tennessee men exited. Franny and LaCorte returned to the Birch Inn where 20 minutes later he received a call to return for the burglars. The criminals had cardboard boxes and pails filled with items, including $50,000 in cash, several ingot silver bars, silver coins and a number of U.S. proof coin sets. They drove to Franny's Newark, Delaware, home where they split the proceeds of the crime. The Tennessee burglars headed home and Franny dropped off LaCorte at the Birch Inn. LaCorte believed his share was $15,000.

Years after the case was closed, Richter was at a retirement party for a southern Chester County law enforcement officer. Richter said he was approached by a guest and told the real value of the items taken in the burglary was $1.5 million and six kilos of cocaine. The burglars found items hidden in bed posts and drawers but missed a lot more of the valuable property, Richter was told.

Dorothy Theodore, owner of the Chadds Ford Hotel, was another crime victim with a link to LaCorte. LaCorte knew the victim's son.

* * *

As the new year began West Chester *Daily Local News* courthouse reporter Bruce Mowday could sense a major break had taken place in the Wyeth case. "There is a constant discernable rhythm associated with courthouses and especially criminal cases and criminal trials," Mowday said. "If the pattern is broken, such as a witness not being present when scheduled to testify or an unexplained break during a trial, there is usually something news worthy taking place." Mowday had that feeling that something was amiss in January 1983.

Mowday covered legal proceedings at the federal courthouse in Philadelphia at 6th and Market streets. One day in early January Mowday unexpectedly saw FBI agent Richter in the lobby of the federal building. The reporter asked the FBI agent about the progress of the Wyeth investigation. Richter didn't divulge the fact the paintings had been recovered. He did forcefully suggest Mowday back off the story for a time because a dangerous criminal was loose and lives were endangered. Without mentioning his name, Richter meant Porter.

Mowday wasn't about to stop pursuing the national story of the Wyeth theft. The reporter had excellent contacts at the Chester County courthouse in West Chester. During his decade of covering legal cases, including the infamous Johnston serial killers,

Mowday gained a reputation for protecting his sources and for fair coverage of stories. For days Mowday went to those sources, including courthouse employees, law enforcement members, elected county officials, judges and attorneys, asking about the Wyeth paintings. By the way some of the sources responded to questions, Mowday was convinced a major break had taken place in the case. All the sources were unusually tight lipped.

One morning, after repeated attempts all failed to uncover the information, Mowday made his daily visit to the Chester County Detectives office seeking news stories. Chief County Detective Charles Zagorskie was in his office and Mowday gained admittance. The reporter, of course, asked about the Wyeth case. Zagorskie had no comment on the record. When Mowday indicated he knew something was afoot, Zagorskie made Mowday an offer. Zagorskie said he would tell Mowday what was going on only if Mowday promised not to print a story until Zagorskie said it was OK to do so. Mowday thought about the offer. This was not a promise he usually made. Mowday realized he had been hounding every contact for days without success. Mowday agreed to Zagorskie's terms and was informed the paintings were safe and sound and the police were in the process of setting up a trap to take Porter into custody.

As Mowday departed the county detective's office, the reporter at least knew what was going on in the case. Within minutes of making the promise to Zagorskie, Mowday was walking back to the courtroom area of the courthouse. Mowday saw noted criminal defense attorney John Duffy approaching him. Duffy was known throughout the region as an excellent trial attorney and handled many noteworthy cases, including a defendant in the federal ABSCAM investigation. ABSCAM was a public corruption investigation by the FBI and U. S. Department of Justice. A convicted con-man videotaped politicians accepting bribes from a fraudulent Arabian company in return for various political favors.

Without being asked a question, Duffy asked Mowday if he had heard the Wyeth paintings had been recovered. If Mowday

had encountered Duffy before entering Zagorskie's office, Mowday would never have promised he would hold the story. The recovery of the Wyeth paintings was big national news.

Mowday faced a professional dilemma. He had a major news story and could under the loose ethical guidelines followed by journalists write a story based on Duffy's tip. Mowday was convinced if he would do so, Zagorskie would believe he had violated his promise of holding the story. If the story had been printed Zagorskie and many of his sources would never again give him a tidbit of information. Was one story worth the many to be had in the future? Mowday was reluctant to discuss the issue with his editors and kept his knowledge to himself. The reporter believed the editors would press him for the story without considering his promise to Zagorskie.

Mowday decided to sit on the story. For a week, until the news was released, Mowday worried that another reporter would print the story, a major story. Mowday possessed a scoop but couldn't in good conscience write the story. No other reporter authored an article in that interval. Mowday had reason to be nervous. People were being informed about the return of the paintings. Mary Landa, The Andrew and Betsy Wyeth Collection Manager, was told weeks before, in December, of the safe return of the artwork.

* * *

Mowday didn't have to wait long for the story to break. Law enforcement officers were devising a trap for Porter. Instead of setting up friends and acquaintances to be victims of crime, this time LaCorte was setting up his criminal buddy Porter for the police. LaCorte telephoned Porter on January 12, 1983, and told Porter to get ready for another big burglary in Pennsylvania.

At 6:00 p.m. on January 14, 1983, members of the Pennsylvania State Police, FBI and Chester County Detectives gathered in the parking lot of the Spinning Wheel Restaurant on Route 41, in Kennett Township, Pennsylvania, near the Delaware line.

They were ready for Porter, who was considered armed and dangerous. "Porter was a pro," Assistant U. S. Attorney Jack Riley said. "He was a burglar. That was what he did. Porter went to the gym and worked out because of his criminal occupation. He had everything down to a science. He kept in great shape, so he could carry more stolen goods. He was able to climb walls and he knew burglary alarm systems. He was a dedicated, experienced professional thief."

Porter was sitting in the driver's seat of a green Lincoln when police arrived. The car was parked in the northeast corner of the restaurant's parking lot when LaCorte arrived in his Cadillac and parked. Porter exited his car with a dark bag and walked to LaCorte's car and entered. At 6:05 p.m. authorities surrounded LaCorte's car and Porter was taken into custody without incident. The black duffle bag carried by Porter contained two screwdrivers, a brown right-hand glove, stethoscope and three portable walkie-talkies.

Taking part in the arrest were FBI agents David Richter and Jim Vaules, Chief County Detective Charles Zagorskie, county detective Mike Carroll and state policemen Robert Martz, Paul Yoder and Tom Cloud. Cloud advised Porter of his rights. Porter was patted down for weapons and Richter handcuffed Porter behind his back.

"He was ready to do some burglaries. We conducted the search in the parking lot of the restaurant and we wanted out of there as soon as possible," Richter said. "I remember debating if I should handcuff him in front or back. Front would have been easier, and we did want him to cooperate with us. Protocol was to cuff him behind his back and that is what I did. During the ride he was squirming. I thought he had to go to the bathroom. He kept moving and fidgeting. It was pitch black in the van."

Cloud drove the van to the state police barracks in Avondale with Yoder and Richter in the back seat. A second search of Porter was conducted at the barracks by Cloud. Two handguns, a .45 caliber and a .25 caliber, were discovered. "I remember the officer in charge at Avondale yelled at me," Cloud said. "Someone could

have been hurt with those guns." Later Porter told Yoder he carried the guns in case he came upon dogs. Porter also said he was squirming in the van in an attempt to get rid of the guns, so he wouldn't be charged with weapons offenses.

Porter didn't say much when he was arrested, according to Richter. Cloud added, "He acted like the professional criminal he was."

Later Porter was taken by Zagorskie and Richter to the Chester County Detectives office in West Chester. Porter declined to talk to police until he called his wife and his attorney. About 10:00 a.m. on January 15, Porter had about a 20-minute conversation with his wife Kathy and informed her he was under arrest. Kathy said she would make plans to immediately fly to Pennsylvania. Porter also called his brother Bob who was living in West Grove. William Porter was not staying long in Pennsylvania. At 12:30 p.m. Richter took Porter to the Gander Hill Prison outside of Wilmington, Delaware. Porter was being held on $250,000 bail.

Two days later William Joseph Porter was taken to the U. S. Marshal's office in Philadelphia, fingerprinted, photographed and processed. He told investigators he was born in West Chester, Pennsylvania on September 5, 1946, and was also known as Junior Umberger. He said he lived on Old Stage Road, Jonesboro, Tennessee, and was the owner of Homeowners Security Systems of Johnson City, Tennessee. His wife is Kathy Bowers Porter. They had a son and daughter. He also had three brothers, Bob, Kenny and Dallas. He didn't serve in the military and had earned a GED diploma.

Porter wasn't the last of the Wyeth conspirators to be taken into custody. On January 25, 1983, Pennsylvania State Policeman Robert Martz talked with Fuller at the Brandywine Hospital, outside of Coatesville. Martz took Fuller to the FBI office and he was interviewed about several crimes, including the theft of valuable platinum from Johnson Mathey, Inc.

The next day Fuller surrendered at the FBI office in Newtown Square, the same day the federal grand jury indicted four Penn-

sylvania men and one from Tennessee. Those five were mushroom grower Guido Frezzo of Avondale; LaCorte of Chatham; Fuller of Coatesville; Sorber of Parkesburg; and Porter of Jonesboro, Tennessee. Franny was named as an unindicted co-conspirator.

Daily Local News reporters Bruce Mowday and Greg Ryan reported the recovery of the paintings in a front-page story on Wednesday, January 26 with the headline "Wyeth art recovered, arrest due."

The next day, January 27, a press conference was held at the Newtown Square FBI office and attended by law enforcement officials and local and national newspaper reporters. Also featured were Andrew and Betsy Wyeth and the returned artwork. A U. S. Department of Justice press release mentioned all paintings were returned in good condition aside from a crease in one painting and some chips in a couple of frames.

U. S. Attorney Peter F. Vaira and John L. Hogan, special agent in charge of the FBI's Philadelphia office, gave special credit to Richter for solving the case. Richter's bosses weren't the only ones praising his investigative work. "That's the man" who recovered the paintings, Betsy said. An iconic image of Betsy talking and pointing her finger at Richter was captured by West Chester *Daily Local News* photographer Bill Stoneback. The photo was printed on the front page of the paper the next day with reporter Mowday's story. The front page with the photo and story was framed and hung in Richter's office.

New York Times reporter William Robbins attended the press conference and his story on January 28 included a photograph of Andrew in front of the returned paintings. Robbins noted that the FBI turned their offices into an art gallery to display the paintings. The lead of Robbins's story read, "Federal agents have recovered $750,000 worth of stolen paintings that thieves were clever enough to steal from artist Andrew Wyeth's house but apparently didn't know how to sell in the intricate world of art."

Andrew told the gathered reporters, "I would say these people were rather naïve about the art world. It seems they ended up

trading among themselves. They realized they had hot coals in their hands." Andrew pointed out the burglars left one valuable painting by his father N. C. Wyeth, *Polar Bear,* in the Granary but took a lithograph done of his son Jamie which was worth a lot less money. When told one of his paintings was traded for a '57 Chevy, Andrew commented, "A Chevrolet, why not a Mercedes Benz?"

Betsy added that she believed the burglar "was very professional." She said, "It was a sinking feeling when I got home. The door was open, and I couldn't believe I had left it open. It was an intrusion into our privacy. They were all gone. I didn't like those blank spaces on the wall." Once the paintings were returned, Betsy said, "I can't look at them enough. It's a miracle."

One of the paintings that held a special meaning for the Wyeths was the *Writing Chair,* done in 1961. It was the painting from which prints were made and given to law enforcement officials upon recovery of the artwork. The theft was a personal loss, Andrew said. "It's not like this is a television set that's been robbed. That can be replaced. A painting is a very personal endeavor, and the loss of them is like the loss of a child."

The *Writing Chair* is set in the room where the burglary occurred and the window through which Porter entered is seen. Painted before the burglary, the *Writing Chair* nevertheless portrays the scene of the crime. Betsy said she cherishes the *Writing Chair* because it portrays the chair in which Andrew sketched.

An article in the Philadelphia *Daily News* on the day after the press conference centered on the burglar, William Porter. The article characterized Porter as a super burglar and "Marathon Man." The story pointed out Porter trained to run long distances, so he could escape any pursuers. Porter was a master of electronic gear and other tools of the second-story trade, according to the article. The *Daily News* quoted a federal prosecutor as saying Porter was one of the most capable burglars investigated by the FBI in the last decade.

New York City gallery owner Frederick Woolworth, who rep-

resented the Wyeths in the art world and a member of the family that began the national Woolworth chain stores, commented the thieves were amateurs in the art world. Woolworth said the burglars should have hid them for years before trying to sell them. Woolworth had some experience on the subject as a decade before more than 50 paintings, including ones by Andrew and Wyeth family member John McCoy, worth a million dollars, were stolen from his Maine summer estate. At the time of the press conference none had been recovered. The *New York Times* quoted Woolworth as saying his extensive collection told the "story of this country."

The FBI valued the stolen Wyeth's paintings at $750,000 but the stated amount was grossly understated by the time they were recovered. When asked if she believed the theft increased the value of the Wyeth artwork, Betsy responded, "Do you think so? Other people have suggested that is so. They do have a history."

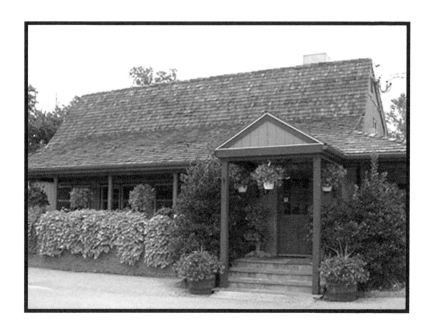

Hank's Place is a popular restaurant in Chadds Ford, Pa., where Andrew and Betsy Wyeth would eat lunch. Henry Shupa, owner of the restaurant, was also a victim of the Wyeth art thieves.

· 9 ·

PROSECUTION

With the Wyeth paintings safely returned and the burglary suspects in custody, the prosecution team turned to the task of finalizing evidence and presenting a case that would secure guilty verdicts in the federal courts.

As with most cases, not everything played out as originally planned.

Just days after the press conference at FBI headquarters, the Wilmington *News Journal* reported that one of the criminals, Gerald "Whitey" Madron was not able to stand trial. Madron, Robbie Matherly's cousin, the paper reported, was being treated at Haverford State Hospital, a hospital for the mentally ill, after twice attempting suicide. Whitey faced the choice of testifying against family members or going to prison.

The prosecution believed Whitey would cooperate as charges mounted against him. The police turned to Robbie for assistance and Robbie admitted committing at least 100 burglaries with Whitey and his father as part of what was known as the M & M gang (Matherly and Madron). Whitey was added as a defendant in the cases Matherly identified.

Whitey chose an option that didn't include turning on his

family or going to jail. He chose to attempt suicide. A court found Whitey mentally incompetent to stand trial and thus also unable to testify for the prosecution if a deal that been struck.

Two of the defendants wouldn't admit their part in the Wyeth crimes and went to trial protesting their innocence. Guido Frezzo, the mushroom company owner, and gambler Sadsbury John Sorber jointly faced a federal jury in May 1983.

Frezzo was arrested on January 26, 1983, after a federal grand jury indicted the mushroom grower in connection with the Wyeth theft. Pennsylvania state policemen Tom Cloud and Paul Yoder joined FBI agents Thomas Dowd and Francis Kenney in going to Frezzo's mushroom business on Route 41 and taking him into custody. Frezzo was escorted to the state police barracks where he called his wife and attorney. He later posted bail and was released while awaiting trial.

Four months after Frezzo's arrest the Chester County businessman was pleading his case in federal court in Philadelphia. For five days Frezzo's attorney John Rogers Carroll argued the prosecution had no evidence that Frezzo conspired with the Wyeth thieves. Emmanuel Dimitriou, Sorber's Reading attorney, contended prosecution witness Benny LaCorte was "garbage" and the government used Hitleresque tactics to prosecute Sorber. Dimitriou also contended the prosecution had no evidence that Sorber purchased the paintings. The prosecution's case did have a missing piece against Sorber: criminal Doug Fuller, a key prosecution witness, had committed suicide the previous month.

On May 27 the jury rendered different verdicts for the defendants. Sorber was acquitted of the charges of interstate transportation of stolen property and conspiracy. The jury found Frezzo guilty of conspiracy and receiving stolen property that had been transported in interstate commerce.

On September 6, 1983, U. S. District Court Judge Raymond Broderick held a sentencing hearing for Frezzo. Broderick's office was flooded with character letters from more than 300 people supporting Frezzo and requesting leniency for the defendant. Frezzo

was called a hard-working man, dedicated family man, patron of the arts and self-taught gentleman who helped friends down on their luck. The letters, according to defense attorney Carroll, indicated Frezzo did a lot more good for the community than evil. Carroll said his client, who admitted purchasing the Wyeth paintings, was a "man totally chagrined for what he has done."

Assistant U. S. Attorney Terry Batty put forth a different version of Frezzo. The prosecutor emphasized the purchasing of the Wyeth paintings wasn't the first crime Frezzo committed. "There is no doubt that Frezzo is a man of influence and wealth," Batty said. "Frezzo's personal real estate holdings in the last five years had been in excess of $1 million. But his considerable influence and wealth have apparently led Frezzo to believe that he is above the law. A millionaire should be held to the same standards as everyone else." Batty also described Frezzo as a shrewd and cunning man whose financial gains came partly from making deals with criminals, buying stolen property and selling it to others. Batty said some of the letters sent to Broderick supporting Frezzo came from people involved in those criminal dealings.

Batty urged Broderick to send Frezzo to prison for 10 years and fine him $20,000.

"We tell people crime doesn't pay, but its people like Mr. Frezzo that make crime happen," Broderick told courtroom spectators as he rendered his sentencing decision. The judge ordered Frezzo to spend five years in prison, five years on probation and pay a $2,000 fine. Broderick contended the prison sentence was a clear message that the same standards of conduct must be applied to the wealthy as well as those not as fortunate.

Even though seeking a sentence of a decade in prison for Frezzo, Batty indicated he believed Broderick's ruling of a five-year sentence for Frezzo was fair.

The sentencing didn't conclude Frezzo's legal battle as he sought a new trial. In February 1985 a hearing was held on Frezzo's request, based on testimony from burglar Bill Porter. Porter, after admitting his part in the crime, said he took all of

the 15 paintings with him to Tennessee the day after Wyeth bur-
glary. If all the paintings were in Tennessee, Frezzo contended he
couldn't have purchased them from LaCorte and Matherly. Frezzo
testified he never saw the paintings.

Kathy Porter Bower, burglar William Porter's ex-wife, reported
that investigators working for Frezzo contacted her in the summer
of 1984 about the Wyeth case. She told FBI agent Richter that she
believed the investigators were trying "to put words in her mouth."
Bower, who changed her name after divorcing Porter, told Richter
she wouldn't allow the Frezzo investigators to come to her house
and she met them at the Holiday Inn in Johnson City, Tennes-
see. Bower told Richter that she had seen several of the paintings
when they were in her husband's possession and she remembers
her husband saying the Wyeths were looking for a missing quilt
and would be willing to pay a lot of money for its return.

Frezzo's effort for a new trial failed as LaCorte and Franny
insisted Porter returned with only 11 of the 15 paintings. Also,
Frezzo's co-defendant, Sorber, decided to testify for the prosecu-
tion even though he was found not guilty at trial. Sorber said
he made $58,000 selling the paintings. Broderick ruled the new
information presented at the hearing was unlikely to result in an
acquittal if Frezzo was retried.

Broderick ordered Frezzo to report to a federal correction insti-
tution on December 31, 1984, to begin his prison sentence.

On April 5, 1983, Porter decided not to fight the charges in
court and entered a guilty plea. The prosecution and defense
couldn't agree on a prison sentence and left that decision to a
judge. Porter then began a public relations campaign to lessen the
amount of years he faced in prison. He began by writing a letter to
Andrew, Betsy and Jamie Wyeth. The next week Betsy turned over
the letter to FBI agent Richter. Porter's letter said he was sorry for
stealing the artwork and deserved incarceration. Porter told the
Wyeths he knew nothing of the famous artistic family before the
theft, but he had come to admire their work, especially the paint-
ing *Shorty*, Porter's favorite. The painting reminded Porter of his

father. Porter said at one point he considered taking the paintings back to the Wyeths.

Porter also had a request for Andrew. Porter, a professed Christian, wanted to start a Christian charity. Porter asked Andrew to paint a picture of him, so he could sell it to raise money for the charity. Andrew didn't respond to the request.

The Wyeth letter was just the first of several Porter wrote to lessen his jail term. One was an obviously insincere and self-serving letter Porter penned to Broderick on June 10, 1983. Porter tried portraying himself as a victim of a broken home and a shy person who stole to impress girls.

Porter informed his sentencing judge that his mother was a Christian and his father an alcoholic. There were many arguments, fights and separations during Porter's childhood and he was an unloved and confused child shuttled between parents. Porter said his dad took him from barroom to barroom as he drank. When he stayed with his mother he was cared for by a babysitter as his mother had to work. Porter said when he was 13 years old, a thief moved into his neighborhood and influenced him to get involved in crime. They committed crimes together and spent time in a reform school. Porter said he stole for several reasons, he needed to do so and because of thrill. Porter was justifying the crimes because of the hurt in his life.

Porter's letter to Broderick stated his dad died when he was 15. Porter wrote he then quit school and went back to stealing to impress girls since he was a shy guy. The next time he was arrested he admitted doing 150 burglaries and agreed to cooperate after being promised help from police. Porter reported he didn't receive any help and served five years in prison where he earned his GED degree.

When Porter was released he had difficulty obtaining and keeping jobs. Porter wrote he fought off temptations and found God. Porter reported that he moved to Tennessee to help his sick mother. He turned back to crime, according to Porter, when Franny contacted him. At that point he was married to a Christian woman

with problems and they had a child. When Porter possessed the Wyeth paintings he considered selling the artwork for a quick $20,000 or $30,000 and fleeing the country with his family but he didn't want to run.

When LaCorte contacted Porter and told him of the letter Betsy Wyeth had written, Porter said he realized the extent of the personal mental stress he was putting the Wyeths through. "After all the excitement was over I was able to look back at the artwork and I began to realize how much of the Wyeths themselves were in the artwork. I felt some of the pain I imagined they were going through. I wanted to see them get them back, so I gave them to LaCorte assuming that he was going to return them. I suspected that LaCorte was working with the authorities then and I was prepared to be arrested and get it over with."

On the day Porter was arrested he insisted he was "in a state of remorse and relief that it was finally over." After his arrest Porter wrote to Broderick that he had rededicated his life to God and had "love for others, for life." He informed the judge that his original intention for getting into the alarm business was to learn how they worked so he could get around them during his burglaries. "But when I realized how riches were creating a larger and larger gap between God and me, I gave up on learning the trade for that reason. I avoided anything that had an alarm in it with a couple of exceptions."

Porter closed his letter to Judge Broderick by writing, "I admit I was a thief, but I was not a rogue." He said he didn't steal from any of his 300 clients, including three jewelry stores. "I admit I haven't been a very good contributor to society." At age 36 Porter said he hoped to change. He signed the letter: "May God grant you the wisdom to make the right decision. Prisoner of Christ, Love, William Porter."

Porter wasn't the only person sending information to Broderick. On June 15, 1983, the day before Porter was sentenced, U. S. Attorney Edward Dennis, who succeeded Peter Viara, and assistant U. S. Attorney Batty filed a sentencing memorandum asking Brod-

erick to impose maximum consecutive sentences on the two cases involving Porter. The Wyeth case would be a 25-year maximum and the Avello burglary would add another decade to Porter's sentence.

One of the reasons for the long sentences were being requested involved the sentencing of cooperating witnesses Franny Matherly and LaCorte. U. S. District Court Judge John B. Hannum, Sr. sentenced Franny to 12 years incarceration. Franny admitted that he and Porter committed the Wyeth burglary as Porter entered the Granary and he was the getaway driver. Franny also said Porter was the lead burglar on the Avello burglary. Franny admitted fencing stolen property for 15 years. LaCorte received a 10-year sentence for his part in the crimes from Broderick.

Porter deserved a longer sentence than his co-conspirators since he refused to cooperate at the time of his guilty plea. Porter's plea was tied to a maximum 20-year prison term. Porter contended he couldn't cooperate because it would hurt his credibility as a Christian lay minister while in prison. Dennis and Batty contended when Porter was committing crimes he was armed and dangerous and "an unusually capable professional burglar." The government believes that Porter is at least one of the most accomplished, if not the most accomplished, of all known burglars on the east coast within the past 10 years.

During the sentencing proceeding Porter again said he had turned to God. Judge Broderick agreed with Dennis and Batty and ordered Porter to spend 30 years in prison, 20 for the Wyeth and Avello thefts and an arson. Porter's main criminal partners also received long prison terms. Judge Hannum sentenced Franny, pursuant to a plea bargain to 12 years in prison. LaCorte pleaded guilty to two counts in the Wyeth case, receiving stolen goods and conspiracy, and received 10 years in prison.

Porter didn't get a break on his sentence. Porter wasn't the only burglar upset with the length of a prison sentence. LaCorte believed he should have received a much lighter sentence than Franny, his co-defendant. LaCorte made his case to a newspaper reporter.

West Chester *Daily Local News* reporter Bruce Mowday contacted LaCorte for comment on the Wyeth investigation and LaCorte penned a letter to Mowday on December 3, 1985, from the low-security United States federal prison in Loretto, Pennsylvania.

LaCorte wrote, "I really can't add too much (about the Wyeth crime). I would suggest you get a transcript of the trial but I'm going to write some facts down about the burglary and also my feelings towards the newspapers." LaCorte wrote that the newspaper articles made him to appear equal in responsibility with Franny and Porter. LaCorte claimed he was involved in only four burglaries, not the multiple crimes committed by his co-defendants. The four burglaries LaCorte admitted committing were the ones at the homes of Theodore, Avello, Wyeth and Fortuno.

"I wasn't involved in the arson case nor the 100 plus or more that (Franny) Matherly and Porter were involved in," LaCorte wrote. "Matherly is 20 plus times more culpable than I am and yet look at the disparity of sentences. Matherly actually got only 17 more months to do than me. There is a story in itself."

"You see, Porter didn't start talking until he had close to one year in prison. Then when Porter started to talk he told them more and more of his and Matherly's involvements. Matherly's involvement became more and more while mine only increased a very, very little."

LaCorte also admitted traveling to Tennessee to meet with Porter concerning the Wyeth paintings. Two of his trips to see Porter were in connection with attempting to obtain money to help Nancy Matherly pay for Franny's lawyer, according to LaCorte.

"So now my involvement is up to 6, no more than 7 (crimes)," LaCorte wrote. "By itself 6-7 involvements is nothing to laugh at or take lightly. And if you look at my sentence and my involvement my sentence is fair. But to compare it with Matherly's, I have been screwed royally. The disparity is completely out of sight. This is what I wrote to Judge Broderick about in September. In my letter I asked him to re-consider. No answer."

"So, in summing up my involvement vs. time served is the severest. I did 1/25th or less of the total crimes committed and Matherly got 25 percent more time than me. Even if I would have served two years and then been released the facts and numbers don't and can't change. My sentence, the severest of all involved. I guess that's my reward (as a chiropractor) for helping sick and poor people. Many I didn't charge!"

In the letter to Mowday, LaCorte did give his version of the Wyeth burglary. LaCorte wrote, "We — me and Fran — were in his kitchen down in Newark. I started to tell him that Andrew Wyeth just got $450,000 for one painting. He then said we should try to get a couple. I told him one or two would be nice. I then told him there would probably be a few at the old mill on Route 100. He then said he would think about it. On another occasion while coming back from West Chester we deliberately drove by the mill and I pointed out the spot where I thought there would be a few paintings. I had no idea that their prized collection would be there, but I was certain that there would be something there. The original plan was to get 1 or 2. We had no plans to sell them and after they were in Bill's possession he and Franny would refer to it as their retirement fund."

LaCorte also wrote that Franny wanted to use the paintings as a bargaining chip for a lesser sentence, the same idea that gambler Vincent Perry acted upon. "Fran had called me when he was at Chester County Prison Farms," LaCorte wrote, "letting me know that he was wanting to get out on bond and get his hands on the pictures. He was going to use them for a bargaining tool, so I gathered at that time. Later on, he let me know that was his plan."

"However, Vince Perry had one in his possession which Doug Fuller had sold to (Sadsbury John Sorber) who in turn sold it to Vince Perry. Doug told me that Perry had sold it to someone in South Philadelphia for $90,000. Then after Perry got busted on gambling charge he went and bought it back."

"While Fran and myself were at the Wilmington jail we met a guy there who also knew Vince Perry. He came in after Doug

committed suicide. He told a story — there was a private party at the Four Winds (a restaurant bar outside of West Chester) with Perry, Sadsbury John and a few others celebrating Doug Fuller's death. This cleared Sadsbury John (of criminal involvement) because Sadsbury John dealt mainly with Doug. The champagne was flowing!"

LaCorte closed the letter, "Sincerely, Ben."

Franny was sentenced in April 1984 to 7 ½ to 15 years in prison and 18 years on probation by Chester County Common Pleas Court Judge D. T. Marrone as part of a plea bargain. The term was to be served at the same time as a 12-year federal sentence Franny was serving in Kentucky. District Attorney James P. MacElree, II told Judge Marrone that Franny's extensive cooperation was a factor in the lenient sentence.

The three main thieves involved in the theft of the paintings from the Wyeth estate were unhappily behind bars. While the Wyeth case was settled, the law enforcement team faced years unraveling the crimes linked to Porter, Matherly and LaCorte.

· 10 ·

CRIMES, CRIMES AND MORE CRIMES

The day FBI agent David Richter, Pennsylvania State Policeman Tom Cloud and the other members of the prosecution team began delving into the circumstances surrounding the theft of the 15 paintings from the Wyeth estate, they couldn't have imagined the number of major crimes that would become part of their investigation.

A press release from the FBI in connection with the Wyeth theft stated, "The case involved the solutions of hundreds of significant burglaries in Pennsylvania, Maryland, Tennessee and Florida." The government stated 27 criminal convictions were obtained from the Wyeth investigation. At the core of this burglary ring were three admitted criminals Franny Matherly, Benny LaCorte and William Porter.

Law enforcement didn't start the investigation from ground zero as police were well aware of the criminals connected with the Johnston and Matherly and Madron (M & M) gangs before the Wyeth theft took place. The Johnston and M & M gangs, Pennsylvania State Policeman J. R. Campbell said, did their own separate crimes but there were common players, such as Franny Matherly and Benny LaCorte.

Some of the members of the M & M gang had unique modus

operandi, MOs as they are known. Those telltale signatures allowed police to easily identify them as perpetrators. Campbell said Whitey Madron would defecate on the floor of places he burglarized, and Larry Matherly used vice grips when he committed crimes. By the striations from the vice grips police knew Larry Matherly was the culprit. Larry couldn't stay out of trouble. "As soon as Larry was released from jail, he would commit additional crimes," Campbell said.

Not all the members of the M & M gang prayed on famous victims and invaded homes while armed with weapons. Campbell recounted the exploits of shoplifter Ruth Matherly Madron. Campbell said police found 500 to 600 pairs of sunglasses at her home during one search. "Toothpaste was lined up like it was a pharmacy," Campbell remembered. The state policeman recalled instances where he would follow Madron from her Pennsylvania home to shopping malls in Delaware. When Madron entered a store, Campbell said he would alert his barracks and someone there would call the store to tell them about the presence of the shoplifter extraordinaire. This was before the age of cell phones, so Campbell couldn't directly contact the store.

At times the criminals would attempt, or at least appear to attempt, to cooperate with police when arrested. "Some people just can't tell the truth," Cloud said. "Some you can't figure out why they are lying to you." A good example was Robbie Matherly. At one point Robbie said he would be contacted when needed by his father, commit the burglary and be paid for his work that very night. Robbie told police he didn't know what happened to the stolen goods after the thefts. He didn't divulge at first that he knew relatives, especially Franny, purchased the stolen items.

Glenn Barnett, a relative of master burglar Bill Porter, was convicted of his part in the Wyeth burglary and other crimes committed by Porter, including fencing stolen weapons. Barnett, who lived in Johnson City, Tennessee, married Porter's sister Barbara.

Barnett told the FBI he first met Franny at the Wooden Shoe Inn with Porter and picked up three of the stolen Wyeth paint-

ings. At one point Barnett was driving Porter's car and found some guns underneath front seat. Barnett asked Porter if he would sell these stolen goods to him and Porter agreed. Barnett then sold the guns. Many of the stolen items were sold to Kenneth Blevins of Stony Creek, Tennessee, who operated a firecracker and pawn shop, according to Barnett. Barnett said he may have purchased stolen good from Porter on 100 occasions.

One crime victim, Treva Armentrout of Whitford, Maryland, told police she had befriended Porter. A security guard at the Peach Bottom nuclear power plant, she had met Porter in the late 1970s and had helped him to be released from jail by giving him a place to stay and a job. Porter lived with Armentrout under a halfway house program administered by the justice system as the last part of a prison sentence he was serving. Porter then aided Armentrout in putting in a burglar system. In April 1981 she was robbed of more than $5,000 in goods. Porter admitted committing the burglary with Dean Matherly and selling the stolen items to Franny Matherly. Porter also admitted to burglarizing the home of a couple who went to the same church as Armentrout. In that crime, Robert A. Jones, a barber, lost $5,000 in stolen items. Jones was uninsured.

When Porter began cooperating with law enforcement in late 1983, he was driven by FBI agent Richter and state policeman Campbell throughout Chester and Delaware counties in Pennsylvania and New Castle County, Delaware, pointing out 30 locations where he committed crimes, including a school in the Avon Grove School District.

Not everyone involved with the gangs was related or long-time crooks. Franny Matherly testified by accident he found West Chester businessman Calvin Jacobs, the former owner of Lenape Park on the Brandywine River, outside of West Chester at his National Gold and Silver Exchange in Exton. "I went to a guy in the Exton Mall who wanted a thumbprint before he would buy my merchandise, so obviously I couldn't deal with him," Franny testified. The fence then left the mall and went to a McDonald's restaurant across from the mall and located in a small plaza

where Jacobs ran his gold and silver exchange. Franny said he sold some silver items to Jacobs that day. Matherly testified he sold items to Jacobs on 25 or 30 occasions and Jacobs never asked for identification.

"On the surface Jacobs's business looked like an honest business," Assistant U. S. Attorney Terry Batty told a federal jury. "Instead it was a storefront for stolen goods. No receipts were given, and Jacobs didn't ask for identification from those who sold him items. Matherly did business with Jacobs because of Jacobs's promise of privacy."

Mike Carson, owner of Carson Antiques on Pine Street, Philadelphia, remembered Jacobs coming into his shop numerous times selling scrap gold and silver, rings busted into pieces and junk silverware. Carson said one year he paid Jacobs $45,078, mostly in cash, but he wrote at least one check. Jacobs preferred cash, according to Carson.

U. S. Attorney Edward S. G. Dennis, Jr. announced a federal grand jury indicted Jacobs in October 1986 of receiving approximately $79,000, worth of stolen goods. Dennis wrote that the case was part of the "so-called 'Matherly gang' investigation by the Newtown Square office of the Federal Bureau of Investigation."

Jacobs went on trial in May 1987 before federal Judge Anthony J. Scirica. In announcing the indictment, Dennis stated Jacobs was charged with receiving stolen silver flatware, 15 oriental rugs worth $74,000 and silver ingots and coins. The stolen items went from Pennsylvania to Delaware and back to Pennsylvania, thus the federal interstate charges.

Batty prosecuted the case and Chester County attorney Albert P. Massey, Jr. was the defense attorney. Testimony was given that Jacobs purchased items from the Hercules Avello and Helen Lodge robberies in Chester County. Avello testified he lost $30,000 in the theft. He told the jury that he had saved silver coins most of his life and gave silver as gifts. "My house was a disaster," Avello said. "Every drawer in the place was upside down."

Thief Benny LaCorte added evidence against Jacobs. LaCorte

said he saw stolen oriental rugs in Jacobs's shop. One of the stolen rugs was valued between $7,000 and $30,000. Victim Mary Ann Kubeck of West Chester testified she went to Jacobs's store and found a charm and other items that were stolen from her. She was a victim of a burglary on Nov. 15, 1981. Kubeck purchased the stolen items from Jacobs.

Jacobs denied knowingly purchasing stolen items. He did admit knowing Franny and seeing the fence six or eight times beginning in August 1981. Jacobs testified he purchased one load of rugs from Matherly for $1,500 but that was the only purchase. During the investigation, Jacobs told Pennsylvania State Policeman James Boyd that he "didn't care who the people are or where the stuff comes from." Jacobs said he wasn't about to start keeping records. Boyd testified that even though other stores were keeping such records Jacobs was not breaking any laws by not recording transactions.

After testimony in the three-week trial concluded, defense attorney Massey attacked Franny in his closing. "The issue of credibility is critical to your decision," Massey argued. "There is no other way of convicting Jacobs other than from Matherly's testimony." Batty countered, "Matherly had nothing to gain by lying and that Jacobs was hiding behind his contended ignorance of the source of the items he purchased from Matherly. This defendant thinks that as long as nobody whispers, 'It's stolen' then he doesn't know."

On May 19, 1987, the federal jury found Jacobs guilty of two counts of receiving stolen property. In September Scirica held a sentencing hearing for Jacobs. The defendant asked for leniency. He said, "I dedicated my life to helping others. I have given of my time, energy and money, not hundreds but thousands of times." Defense attorney Massey pointed out his client had no prior record. Prosecutor Batty asked for substantial jail time for Jacobs. Batty said, "Mr. Jacobs should not be treated with sympathy. It is obvious there are two Calvin Jacobs's." Batty said the defendant's dark side had to be addressed.

Scirica sided with Batty and sentenced Jacobs to four years in prison and five years of probation. Scirica called Jacobs an

"integral part" of a major burglary ring. "Burglars need persons such as you in order to make their enterprises profitable."

Wanda "Ruth" Matherly Madron blamed Jacobs for her legal troubles in a federal criminal case involving two counts of interstate transportation of stolen property. Madron didn't present any defense witnesses but claimed Jacobs framed her. Madron was found guilty of the two counts.

Madron and Eileen Weaver, a part-time beautician, were indicted on charges of defrauding an insurance company by inflating losses due to a burglary. U. S. Attorney Edward S. G. Dennis, Jr., publically announced the indictment on December 30, 1986. The crime was committed by Robbie Matherly who took $400 and three pieces of jewelry. Madron and Weaver, made the house to look like someone had torn it apart looking for goods. Madron filed an insurance claim with Penn Mutual Fire Insurance Company listing 60 items taken worth more than $7,000. Weaver received a microwave oven and a diamond broach for her assistance in the crime, according to court records.

Much of the high-end stolen property ended up in stores in New York City. "The oriental rugs went to Fifth Avenue where they were sold," Richter said. "The criminals knew the quality of the items they stole. They had guns, antiques, silver, rugs and furniture. They were involved in thefts for many years and they had the contacts to unload the stolen items."

In March 1983 FBI agents interviewed New York City antique store owner Marvin Kagan. Kagan checked his records and found a Dr. Benedict LaCorte of Chatham, Pennsylvania, had sold him an oriental rug for $2,000. Kagan later sold the rug to another dealer. Kagan said he was introduced to LaCorte by Francoise Nunnalle. Nunnalle was paid $200 by Kagan for the introduction to LaCorte.

When contacted by FBI agents at her home in New York City, Nunnalle said she was a self-employed art broker. She had placed an ad in the West Chester *Daily Local News* stating she was interested in purchasing 19th century European paintings. LaCorte responded to the ad saying he had a painting by Cornelius Bouter.

Nunnalle visited LaCorte's home and purchased the painting for $300. Later LaCorte contacted her about the oriental rug. Nunnalle said she went to see Kagan with LaCorte and a man she believed owned the rug. Kagan was told the rug was being offered for sale so a gambling debt could be paid.

The investigation resulted in indictments against other people with connections to the burglary ring. They included Frank and Janet Gazzerro of Downingtown, mushroom company owner Anthony Fragale, Wanda Madron, Barnett, Blevins and Dean Matherly of Tennessee. One of the items taken was an $18,000 diamond ring from a home in Avondale.

In April 1986 Frank and Janet Gazzerro were convicted of receiving stolen property in connection with $83,000 worth of stolen rugs, a violin, furs, jewelry and television sets. The Gazzerro husband and wife team wasn't only interested in high-end goods. They were indicted along with David Harry Sampson of taking a truckload of canned mushrooms valued at $16,000 in August 1975. The indictment said the Gazzerros purchased the mushrooms in Gap, Pennsylvania.

Before being convicted, Janet and Frank told Richter they wanted to come clean about their previous illegal activities. They admitted knowing Franny for about 15 years and purchasing about 10 stolen tractors from him, along with clothing, watches and Hummel figurines. Stolen tractors were a specialty of the Johnston gang as more John Deere tractors were stolen in the southern Chester County area than the rest of the country combined. Janet admitted purchasing eight sets of china from Franny as well as shoplifted meat and perfume. She denied but later admitted purchasing two fur coats from Franny. The Gazzerros denied receiving the stolen rugs and violin.

Janet's criminal co-conspirators Franny, Porter and Roy Myers all described her as an extremely strong-willed person who would often express her opinions vehemently, if not abusively. At one point Janet said she would like to get her hands on Matherly because he was the cause of her being charged with crimes.

The Gazzerros were also victims of crime, as they contended Porter and Franny stole their tractor. The criminals told the couple the theft was a joke. Frank said at one time he did see Franny and David Johnston, one of the leaders of the Johnston gang, exchange money. Frank said Franny told him the money was to be used to murder James Mark, a southern Chester County businessman with criminal ties to the Johnston gang. Frank also claimed he was told a paid assassin was hired to kill another witness cooperating against the Johnstons, Roy Myers, Bruce Johnston, Sr.'s brother-in-law.

Mushroom grower Fragale returned nine oriental rugs he obtained from LaCorte in 1983. He told FBI agents that he had given some of his rugs to his daughters. In 1986 Judge Scirica found Fragale not guilty of receiving stolen property in connection with the rugs. Fragale didn't escape a conviction in Pennsylvania courts.

In February 1984 Chester County Common Pleas Court Judge Robert S. Gawthrop, III sentenced Fragale to three-to-23 months in prison for receiving a stolen digital thermometer used in the mushroom business. The theft was from another mushroom company. Gawthrop said Fragale was a "significant link in the criminal chain which strips citizens of their property." One witness in the case was LaCorte. LaCorte told the jury Fragale asked him to come to his home because a person LaCorte believed was associated with a Philadelphia mob person was interested in buying fur coats.

Fragale, who had an association with the Johnston gang, told Gawthrop he was "sorry from the bottom of his heart and it won't happen again." The defense unsuccessfully argued Fragale should be sent to prison since he weighed 480 pounds, had high blood pressure and needed help to get showered and dressed. "It's no joke," Fragale said, "I'm scared. It petrifies me to think of being locked up. I would like to have another chance."

"Obesity doesn't allow anyone to commit a crime with impunity," Gawthrop commented.

For years Porter committed crimes with impunity and not all of them were burglaries. Porter was indicted by the federal government in connection with an arson for hire in August 1983. U. S.

Attorney Edward S. G. Dennis, Jr.'s announcement named Porter; Billy Dugger of Butler, Tennessee; and two Chester County men. They were charged with the federal crimes of mail fraud and interstate travel in aid of racketeering. Franny was involved in the crime but not indicted, according to the federal government.

The indictment stated an arson took place at the home of a Bear, Delaware, resident and an insurance claim of almost $300,000 was made with Travelers Insurance. The homeowner was indicted but acquitted at a trial. Franny was contacted about facilitating the arson and he contacted Porter. Porter indicated he would do the arson if he was guaranteed no one would be home at the time of the fire. Porter was told he could take what he wanted from the home, including the 1982 Chevrolet Cavalier in the garage. The car keys were left in the vehicle.

On July 16, 1982, Dugger and Porter drove from Tennessee and checked into the McIntosh Motor Inn in Newark, Delaware. Late in the evening four, five-gallon green plastic jugs filled with diesel fuel were taken to the home. Nancy Matherly told the FBI that Porter called her husband Franny about midnight one day to get gasoline cans from their garage. Porter came to their home on Marrows Road, Newark, and took the gas cans. He returned some time later and took a shower, according to Nancy. Porter's clothes smelled of gasoline, so they were washed. Franny admitted he received $1,300 for the arson.

The back door was left unlocked as the family was on vacation in Avalon, New Jersey. In the early morning hours of July 17, 1982, Porter and Dugger entered the home and committed the crime, according to federal court records. The criminals took a television, stereo set, radio, furniture and clothes and put them in the car before setting the arson. The fire was reported by a neighbor, Delaware State Policeman Timothy Hadley. Christiana Fire Company responded to the home at 4:00 a.m. Hadley reported he was getting ready for bed after he finished working an extra shift when he noticed a car in his neighbor's driveway. Hadley thought the family had returned from vacation. When Hadley saw the car depart, the officer went to bed.

James Dugger later told police that Porter and Billy Dugger asked him to accompany them on a job to Pennsylvania. James Dugger believed it was a burglary but when he discovered it was to be an arson he backed out of the job. James said his mother almost died in a fire and he was afraid of fires. He said he dropped off Porter and Billy in a neighborhood in Delaware and went to a motel to register.

Detective Thomas Bailor of the New Castle County Police Department investigated and obtained a search warrant the next day. The accompanying affidavit stated the fire was arson and an accelerant used, kerosene or another such liquid. Also, no sign of a forced entry was visible. The homeowner was alerted that his home had burned and returned from New Jersey. The homeowner told Bailor that two weeks prior to going on vacation he received a threatening phone call from a former employee who was fired from a job.

Porter admitted to Richter and Batty that he took part in the arson and agreed to do so for $1,200. Porter confirmed he got the green plastic gas cans from Franny and filled them with diesel fuel at a truck stop on Interstate Route 95. Porter said they had to delay setting the fire because a neighbor returned home early in the morning and they had to wait for the neighbor to go to sleep. After the arson, the stolen items were loaded in a van and the car was left with a relative of the Dugger duo for disposal.

During the homeowner's trial, the defendant, who worked at a car dealership, claimed he was framed by Franny because the homeowner refused to give Franny credit to purchase a car.

FBI agent Carl Wallace said a criminal gang used a Kennett Square company to clean up fires after arsons. Insurance companies, usually Allstate, would pay for the damage. State policeman Tom Cloud said the insurance company was known as the Allstate bank because of the money paid out on the claims. Insurance fraud wasn't limited to arson. LaCorte and Franny Matherly told the FBI a "pretend" hijacking of 10 lawn tractors was arranged at the International Harvester dealership run by James Mark in West Grove. The tractors were taken to a salvage yard near Allentown and the theft was reported the next day to state police.

The tractors were sold to brothers operating several large auto salvage junkyards in Pennsylvania. The Wyeth theft investigation included all three of the brothers. Three cooperating witnesses, Franny, LaCorte and Roy Myers said the brothers received millions of dollars of stolen goods, including antiques, jewelry, gold, silver, stolen farm equipment and hijacked truckloads of meat. In October 1986 a federal grand jury indicted two of the brothers while the third had died by the time of the indictment. One brother went to trial and was acquitted.

Assistant U. S. Attorney Terry Batty prosecuted the case and one of the crime victims, Julia Bissell, testified the antiques stolen from her Tea House in Chadds Ford were valued at approximately a half million dollars. "The people who robbed me knew what they wanted," Bissell testified. "They left all of the English pieces and all the reproductions and they took only good American antiques." Two of the pieces stolen were antique wooden Indian statues. LaCorte said he stole the wooden Indian statues along with criminal Bowman Darrell and sold them to two of the junkyard-owning brothers.

Other crimes federal authorities linked to the junkyard brothers included the receiving of stolen goods from the theft of $32,000 in items from Schiffer Antiques in Exton, Pennsylvania; jewelry taken from a London Grove, Chester County home; and $12,000 worth of cigarettes taken from a Rising Sun, Maryland liquor store. LaCorte admitted selling stolen goods to one of the brothers on 25 to 30 occasions in a three-year period. Edward Otter, an admitted fence of stolen property for the Johnston gang, said stolen items were unloaded at a junkyard and loaded on a truck owned by one of the brothers and taken to New York City. Otter testified Bruce Johnston, Sr. told him two of the brothers were the biggest volume outlet for the goods stolen by the Johnston gang.

The two junkyard brothers denied committing any of the crimes with one stating, "I hope to drop dead and never see my grandchildren or children again in my life, if I did."

One of the leads on a major crime developed through the

Wyeth investigation couldn't be verified. The information came from Doug Fuller just months before he committed suicide. Fuller said quantities of the valuable metal, platinum, was being stolen by employees of the Johnson Matthey company and fenced by Chester County criminals, including himself. Fuller told Pennsylvania State Policeman Robert Martz that he met a guy who worked for Johnson Matthey at the 10 Downing Street Restaurant in Downingtown. Fuller's contact was later fired from Johnson Matthey for drinking.

Johnson Matthey is a multinational chemicals and sustainable technologies company headquartered in England. The company operated a plant in West Whiteland, Chester County. Platinum is a precious metal used in manufacturing of various products, including autocatalysts and pollution control systems. The metal traded between $1,500 and $1,600 an ounce at the time of the thefts.

"After we obtained the first Wyeth painting from Fuller we were told of the theft of platinum," Richter said. "We checked with Johnston Matthey officials and they weren't aware that platinum was missing."

In reality, the company had lost at least $2.5 million dollars' worth of the precious metal. The crime would be discovered and prosecuted in the next decade and involved connections to the Johnston and M & M gangs.

One of the people caught up in the platinum crime was Billy Guthrie, a well-known Chester County bartender who worked at various restaurants in the county, including the one operated by George Malle in Downingtown. One of Guthrie's early jobs was at La Cocotte, a fine French restaurant in West Chester favored for lunch by Johnston trial court Judge Leonard Sugerman and some members of the Johnston gang prosecution team. Guthrie recalled serving Andrew Wyeth in the same establishment.

At other bars Guthrie's customers included serial murderer Bruce Johnston, Sr. and members of his gang. "I didn't realize they were trouble," Guthrie said. "I also didn't know about the paintings being stolen until way later with the platinum stuff. At that

time, I was interested in drinking and chasing women." Guthrie's pursuit of women was interrupted when he served a prison term for taking part in the platinum theft.

FBI agent Carl Wallace gave some details of the theft plot of the precious materials. Melters would work with the platinum but when finished the pots weren't totally cleaned. The residue from the pots would be melted down and the metal then placed in broom handles. Janitors weren't forced to go through security with brooms and other cleaning equipment. The platinum was smuggled out of the plant by the janitors and sold to businessmen, including a beer distributor from the Downingtown area. When the plot was discovered, law enforcement charged five employees with conspiring to smuggle bars of platinum out of the plant in the hollowed-out handles of work dollies. The men then shifted the bars to go-betweens who in turn sold it to jewelers and others.

Guthrie admitted he was trying to make some money by being a middleman. He was paid $1,000 a trip to deliver the platinum to Philadelphia. Guthrie said he had to work many hours at a bar to make that much money.

The crime was made known to the FBI by Thomas M. Baldwin, owner of a well-known book store just outside of West Chester. Baldwin handed more than 60 ounces of stolen platinum worth $20,000 to the FBI. Guthrie said he was the one who told Baldwin of the availability of the platinum. More than $900,000 worth of platinum passed through a company Baldwin created known as Carerra 911, according to law enforcement. Baldwin, who wasn't charged, maintained he was innocent and contacted the FBI when he had reason to believe the metal was stolen.

Seven defendants were convicted of taking part in the theft and received sentences ranging from probation to almost a year in prison. Many also received lengthy probation sentences and were ordered to pay restitution. Law enforcement believed the mastermind of the theft was Mario D'Addezio, who worked as a melter at the plant. He died in a car accident in Italy before being prosecuted.

Wyeth Family Chart

Newell Convers Wyeth
1882-1945
m.
Carolyn Brenneman Bockius
1886-1973

Henriette Wyeth
1907-1997
m.
Peter Hurd
1903-1984

Carolyn Wyeth
1909-1994
m. 1941-1952
Francesco Joseph Delle Donne
1919-2007

Nathaniel Convers Wyeth
1911-1990

Ann Wyeth
1915-2005
m.
John W. McCoy
1910-1989

Andrew Newell Wyeth
1917-2009
m.
Betsy Merle James
1921-

Ann Brelsford
1940-
m. 1961-1979
George A. Weymouth
1936-2016

Nicholas Wyeth
1943-

Jamie Wyeth
1946-
m.
Phyllis Mills Wyeth
1940-2019

EPILOGUE

The stolen Wyeth paintings were safely returned and for years have been enjoyed by their rightful owners and the members of the public. In 1984 the Brandywine River Museum of Art celebrated the opening of a new wing, the Andrew Wyeth Gallery, with an exhibition, which included the *Writing Chair*, one of the pieces of art stolen from the Wyeths.

All pieces of the Wyeth's collection of Pennsylvania work have been removed from the Wyeth residence and now reside in the Brandywine River Museum of Art.

A press release from the museum stated, "The art theft, which was front page news in 1982, involved 15 works, seven by Andrew Wyeth. The FBI investigated the crime for months, and the Wyeths despaired of ever recovering their treasured paintings." The release said the painting *The Writing Chair* was a favorite of both Andrew and Betsy and depicted the scene of the crime. Some 200 paintings were exhibited in the show, a good many seen by the public for the first time.

Jamie, after the death of his father Andrew, carries on the family's artistic tradition. Other Wyeth disciples, including Karl Kuerner who was instructed by both Andrew and Carolyn Wyeth, help keep the Brandywine tradition alive.

Art theft continues to plague society. A recent report stated only 5 to 10 percent of stolen artworks are ever recovered. Unlike the criminal crew that stole the Wyeth paintings, the statistic indicates most art thieves are professionals and find homes for the pilfered works of art.

Investigative tools have greatly progressed since the 1982 Wyeth theft. In the United States the FBI and many cities have special art units as do England, France and other countries. There is great cooperation among agencies, but major thefts remained unsolved. The most noted unsolved crime took place at the Isabella Stewart Gardner Museum. An attempt to produce information by doubling a reward to $10 million for a short time in 2017 failed to produce assistance in solving the mystery of the missing masterpieces.

The criminals from the Wyeth theft have all served their jail time for the crimes. Some have since died. Franny Matherly died in August 2018 as this book was being finalized. Benny LaCorte died two months earlier.

The investigators have all retired. FBI agent David Richter and Pennsylvania State Policeman Tom Cloud, along with other former law enforcement officials, formed a private investigative office. Some of the attorneys involved in the case are still practicing law.

The world is a much better place because of the work of the law enforcement team and the creations of talented artists.

BIBLIOGRAPHY

Edsel, Robert M., *The Monuments Men: Allied Heroes, Nazi Thieves, and the Greatest Treasure Hunt in History,* Center Street, Hachette Book Group, New York, New York, 2009.

Kuerner, Karl, *Beyond The Art Spirit,* pending publication.

Houpt, Simon, *Museum Of The Missing,* Madison Press Books, Toronto, Canada, 2006.

Junker, Patricia, and Lewis, Audrey, *Andrew Wyeth in Retrospect,* Brandywine River Museum of Art and the Seattle Art Museum in association with Yale University Press, New Haven, Connecticut and London, England, 2017.

McShane, Thomas, *Stolen Masterpiece Tracker,* Barricade Books, Fort Lee, New Jersey, 2006.

Meryman, Richard, *Andrew Wyeth A Secret Life,* HarperCollins Publishers, Inc., New York, New York, 1996.

Mowday, Bruce E., *Jailing the Johnston Gang: Bringing Serial Murderers to Justice,* Barricade Books, Fort Lee, New Jersey, 2009.

Michaelis, David, *N. C. Wyeth: A Biography.* Alfred A. Knopf, New York, New York, 1998.

Pitz, Henry C., *The Brandywine Tradition,* Houghton Mifflin Company, Boston, Massachusetts, 1969.

INDEX

A COP'S TALE: NYPD THE VIOLENT YEARS
Jim O'Neil and Mel Fazzino

A Cop's Tale focuses on New York City's most violent and corrupt years, the 1960s to early 1980s. Jim O'Neil–a former NYPD cop –delivers a rare look at the brand of law enforcement that ended Frank Lucas's grip on the Harlem drug trade, his cracking open of the Black Liberation Army case, and his experience as the first cop on the scene at the "Dog Day Afternoon" bank robbery. A gritty, heart-stopping account of a bygone era, *A Cop's Tale* depicts the willingness of one of New York's finest to get as down-and-dirty as the criminals he faced while protecting the citizens of the city he loved.

$24.95 – Hardcover – 978-1-56980-372-1
$16.95 – Paperback – 978-1-56980-509-1

BLACK GANGSTERS OF CHICAGO
Ron Chepesiuk

Chicago's African American gangsters were every bit as powerful and intriguing as the city's fabled white mobsters. In this fascinating narrative history, author Ron Chepesiuk profiles the key players in the nation's largest black organized crime population and traces the murderous evolution of the gangs and rackets that define Chicago's violent underworld.

$24.95 – Hardcover – 978-1-56980-331-8
$16.95 – Paperback – 978-1-56980-505-3

BLOOD AND VOLUME: INSIDE NEW YORK'S ISRAELI MAFIA
Dave Copeland

Ron Gonen, together with pals Johnny Attias and Ron Efraim, ran a multimillion-dollar drug distribution and contract murder syndicate in 1980s New York. But when the FBI caught up, Gonen had to choose between doing the right thing and ending up dead.

$22.00 – Hardcover – 978-1-56980-327-1

BRONX D.A. TRUE STORIES FROM THE DOMESTIC VIOLENCE AND SEX CRIMES UNIT
Sarena Straus

If you dealt with violence all day, how long would it be before you burned out? Sarena Straus was a prosecutor in the Bronx District Attorney's office, working in an area of the Bronx with the highest crime and poverty rates in America. This book chronicles her experience during her three-year stint with the Domestic Violence and Sex Crimes Unit, combating crimes and women and children and details how and why she finally had to give up the job.

$22.00 – Hardcover – 978-1-56980-305-9

CIGAR CITY MAFIA: A COMPLETE HISTORY OF THE TAMPA UNDERWORLD
Scott M. Deitche

Prohibition-era "Little Havana" housed Tampa's cigar industry, and with it, bootleggers, arsonists, and mobsters–plus a network of corrupt police officers worse than the criminals themselves. Scott M. Deitche documents the rise of the infamous Trafficante family, ruthless competitors in a "violent, shifting place, where loyalties and power quickly changed."

$16.95 – Paperback – 978-1-56980-287-8

CONFESSIONS OF A SECOND STORY MAN: JUNIOR KRIPPLEBAUER AND THE K&A GANG
Allen M. Hornblum

From the 1950s through the 1970s, the ragtag crew known as the K&A gang robbed wealthy suburban neighborhoods with assembly-line skills. Hornblum tells the strange-but-true story thru interviews, police records and historical research, including the transformation of the K&A Gang from a group of blue collar thieves to their work in conjunction with numerous organized crime families helping to make Philadelphia the meth capital of the nation.

$16.95 – Paperback – 978-1-56980-313-4

DOCK BOSS
Eddie McGrath and the West Side Waterfront
Neil G. Clark

At a time when New York City's booming waterfront industry was ruled by lawless criminals, one gangster towered above the rest and secretly controlled the docks for over thirty years. *Dock Boss: Eddie McGrath and the West Side Waterfront* explores the rise of Eddie McGrath from a Depression Era thug to the preeminent racketeer on Manhattan's lucrative waterfront. McGrath's life takes readers on a journey through the tail-end of Prohibition, the sordid years of violent gang rule on the bustling waterfront, and finally the decline of the dock mobsters following a period of longshoremen rebellion in the 1950s. This is the real-life story of the bloodshed that long haunted the ports of New York City.

$17.95 – Paperback – 978-1-56980-813-9

DOCTORS OF DEATH
TEN TRUE CRIME STORIES OF DOCTORS WHO KILL
Wensley Clarkson

These mystifying and spine-tingling stories are just what the doctor ordered and they are all true. *Doctors of Death* presents ten hair-raising real life accounts of killing and mayhem in medical training ultimately causing others to die. With a sharp eye for the sort of detail that only true cases can have, they are woven together with some of the most horrifying killings that ever occurred.

$17.95 – Paperback – 978-1-56980-806-1

FRANK NITTI:
THE TRUE STORY OF CHICAGO'S NOTORIOUS "ENFORCER"
Ronald D. Humble

Frank "The Enforcer" Nitti is arguably the most glamorized gangster in history. Though he has been widely mentioned in fictional works, this is the first book to document Nitti's real-life criminal career alongside his pop culture persona, with special chapters devoted to the many television shows, movies and songs featuring Nitti.

$24.95 – Hardcover – 978-1-56980-342-4

GAMING THE GAME: THE STORY BEHIND THE NBA BETTING SCANDAL AND THE GAMBLER WHO MADE IT HAPPEN
Sean Patrick Griffin

In June 2007, the FBI informed the NBA that one of its referees, Tim Donaghy, was the subject of a probe into illegal gambling.

With Donaghy betting on games he officiated, a trail unraveled that led to the involvement of Donaghy's childhood friend and professional gambler Jimmy Battista. Researched with dozens of interviews, betting records, court documents and with access to witness statements and confidential law enforcement files, this book is a "must-read" for any NBA fan.

$16.95 — Paperback — 978-1-56980-475-9

GANGSTER CITY: THE HISTORY OF THE NEW YORK UNDERWORLD 1900-1935
Patrick Downey

This is an illustrated treasure trove of information about New York City's gangsters from 1900 through the 1930s. Told in depth are the exploits of Jewish, Italian and Chinese gangsters during New York City's golden age of crime. No other book delivers such extensive detail on the lives, crimes and dramatic endings of this ruthless cast of characters, including Jack "Legs" Diamond and the sadistic Dutch Schultz.

$16.95 — Paperback — 978-1-56980-361-5

GANGSTERS OF HARLEM: THE GRITTY UNDERWORLD OF NEW YORK'S MOST FAMOUS NEIGHBORHOOD
Ron Chepesiuk

Author Ron Chepesiuk creates the first comprehensive, accurate portrait of Harlem gangs from their inception, detailing the stories of the influential famed gangsters who dominated organized crime in Harlem from the early 1900s through the present. In this riveting documentation, Chepesiuk tells this little known story through in-depth profiles of the major gangs and motley gangsters including "Nicky" Barnes, Bumpy Johnson and Frank Lucas.

$16.95 — Paperback — 978-1-56980-365-3

GANGSTERS OF MIAMI: TRUE TALES OF MOBSTERS, GAMBLERS, HIT MEN, CON MEN AND GANG BANGERS FROM THE MAGIC CITY
Ron Chepesiuk

Miami has been the home for a colorful variety of gangsters from its early days to the modern period. These include the notorious smugglers of the Prohibition era, famous mobsters like Al Capone and Meyer Lansky who helped make Miami a gambling Mecca, the Cuban Mafia which arrived after Cuba fell to Castro, the Colombian cartels during the cocaine explosion, the Russian mafia after the fall of the Soviet Union, and the street gangs that plagued Miami after the advent of crack cocaine.

$16.95 — Paperback — 978-1-56980-500-8

I'LL DO MY OWN DAMN KILLIN': BENNY BINION, HERBERT NOBLE AND THE TEXAS GAMBLING WAR
Gary W. Sleeper

People know of the notorious Benny Binion for opening the Horseshoe and becoming the most successful casino owner in Las Vegas. But before he became the patron saint of World Series Poker, Binion led the Texas underground in a vicious, nefarious gambling war that lasted over fifteen years. Author Gary Sleeper presents the previously unseen details of Benny Binion's life leading up to his infamous Las Vegas days, when he became the owner of the most successful casino in the world.

$16.95 — Paperback — 978-1-56980-321-9

IL DOTTORE: THE DOUBLE LIFE OF A MAFIA DOCTOR
Ron Felber

The inspiration for Fox TV's drama series, "Mob Doctor," **IL DOTTORE** is the riveting true story of a Jewish kid from

BARRICADE BOOKS TRUE CRIME

the Bronx who became a Mafia insider and physician to top NY Mafia dons such as John Gotti, Carlo Gambino, Paul Castellano, and Joe Bonanno. Eventually, he had to make a choice between loyalty to the mob and remaining true to his Hippocratic Oath, all under the watchful eye of New York's top federal prosecutor, Rudolph Giuliani.

$16.95 – Paperback – 978-1-56980-491-9

JAILING THE JOHNSTON GANG: BRINGING SERIAL MURDERERS TO JUSTICE
Bruce E. Mowday

This is the inside story of the dedicated law enforcement team that brought to justice serial murderers Norman, David and Bruce A. Johnston Sr. For more than a decade the Johnston Gang terrorized communities throughout the East Coast of the U.S. by stealing millions of dollars worth of property. But in 1978, fearing that younger members of the gang were going to rat them out, the brothers killed four teenagers and nearly killed Bruce Sr.'s own son.

$16.95 – Paperback – 978-1-56980-442-1

LUCKY LUCIANO: THE MAN WHO ORGANIZED CRIME IN AMERICA
Hickman Powell

He was called the Father of Organized Crime. Born in Sicily and reared in poverty he arrived with his family on New York's Lower East Side in the early 20th century. He grew up among Irish, Jewish and Italian youths dedicated to crime, some of them going on to become world class thugs. This book is written by a top investigative reporter who followed Luciano's trial from its inception to the jury verdict. He not only interviewed Luciano but also the assorted prostitutes and pimps who testified against him. Lucky Luciano was respon-

sible for the infamous Atlantic City gathering of th nation's top mobsters that included Al Capon Meyer Lansky and Frank Costello and where the were persuaded to run crime as a busines With new photographs.

$16.95 – Paperback – 978-1-56980-900-6

MILWAUKEE MAFIA: MOBSTERS IN THE HEARTLAND
Gavin Schmitt

Milwaukee's Sicilian underworld is something few people speak about in polite company, and even fewer people speak with any authority. Everyone in Milwaukee has a friend of a friend who knows something, but they only have one piece of a giant puzzle. The secret society known as the Mafia has done an excellent job keeping its murders, members and mishaps out of books. Until now.

$16.95 – Paperback – 978-0-9623032-6-5

MURDER CAPITAL Madison Wisconsin — The Mafia Under Siege

Gavin Schmitt

Murder Capital explores Prohibition-era Madison, Wisconsin. Per capita, Madison was the most violent and deadly city in the United States during the 1920s. Along with the usual suspects (bootleggers), Madison was unique in its strong Ku Klux Klan presence. In the background was a prominent judge, overseeing Mafia cases by day, but by night taking illegal loans from these very same criminals. In effect, the Judge tied his own hands and the violence was allowed to continue unabated.

$17.95 – Paperback – 978-1-56980-225-0

BARRICADE BOOKS TRUE CRIME

MURDER OF A MAFIA DAUGHTER
THE LIFE AND TRAGIC DEATH OF SUSAN BERMAN
Cathy Scott

Susan Berman grew up in Las Vegas luxury as the daughter of Davie Berman, casino mogul and notorious mafia leader. After her father died she learned about his mob connections. When Kathie Durst, the wife of her good friend, Robert Durst, mysteriously disappeared Durst was a prime suspect but the case was never solved. After the Kathie Durst case was reopened, the DA wanted to question Susan about what she knew regarding a phone call Kathie supposedly made to her medical school dean saying she was sick and wouldn't be at school. Soon after the Kathie Durst case was reopened, Susan Berman was found dead, shot in the back of head. No forced entry, no robbery, nothing missing from her home.

$17.95 — Paperback — 978-0-934878-49-4

SHALLOW GRAVE
'THE UNSOLVED CRIME THAT SHOOK THE MIDWEST'
Gavin Schmitt

An upright citizen kidnapped in public and dumped in a shallow grave. A police chief's wife arrested for murder. A mobster kidnapped and threatened by the FBI. And an ongoing corruption probe looking at everyone from the lowest rookie all the way up to judges and prosecutors. What is going on in small town America? Follow the exploits of the police, FBI and Bobby Kennedy himself as they try to put together the pieces and catch the bad guys… if they can.

$17.95 — Paperback — 978-1-56980-808-5

STEALING WYETH
Bruce Mowday

Andrew Wyeth is one of the best known 20th century American artists in the world with his works being sought after by art collectors worldwide. His father, N. C., and son, Jamie, are integral parts of the best known American family of artists. A gang of thieves decided to steal an original Wyeth painting for their "retirement" and engaged a professional cat burglar (who was responsible for more than 1,500 crimes during his criminal career) to steal a Wyeth painting. The theft resulted in taking 15 paintings from the Wyeth estate in picturesque Chadds Ford, PA. The search for the paintings takes the investigators throughout the U.S. and involves dangerous thieves, gamblers, drug dealers and murderers. In the process of tracking down the thieves and the paintings, hundreds of other crimes were solved.

$24.95 — Hardcover — 978-1-56980-826-9

STOLEN MASTERPIECE TRACKER: INSIDE THE BILLION DOLLAR WORLD OF STOLEN MASTERPIECES
Thomas McShane with Dary Matera

Legendary undercover FBI agent Thomas McShane is one of the world's foremost authorities on the billion-dollar art theft business. For thirty-six years, McShane matched wits with some of the most devious criminal masterminds of the 20th and 21st centuries. Here he presents a unique memoir that gives readers a thrilling ride through the underworld of stolen art and historical artifacts. Written with veteran true crime author Dary Matera, this captivating account is as engaging as it is informative.

$17.95 — Paperback — 978-1-56980-519-0

TERRORIST COP: THE NYPD JEWISH COP WHO TRAVELED THE WORLD TO STOP TERRORISTS
Mordecai Z. Dzikansky with Robert Slater

Terrorist Cop is a colorful, haunting and highly graphic tale of retired NYC Detective First Grade Morty Dzikansky. Dzikansky first patrolled Brooklyn streets with a yarmulke on his head. A rise through the ranks would eventually bring him to Israel, monitoring suicide bombings post 9/11. It was part of Commissioner Ray Kelly's plan to protect New York from further terrorist attacks, but it led to Morty becoming a victim of post traumatic stress disorder.

$24.95 – Hardcover – 978-1-56980-445-2
$17.95 – Paperback – 978-1-56980-160-4

THE JEWS OF SING SING
GOTHAM GANGSTERS AND GONUVIM*
Ron Arons

Sing-Sing prison opened in 1828 and since then, more than 7000 Jews have served time in the famous correctional facility. The Jews of Sing-Sing is the first book to fully expose the scope of Jewish criminality over the past 150 years. Besides famous gangsters like Lepke Buchalter, thousands of Jews committed all types of crimes—from incest and arson to selling air rights over Manhattan—and found themselves doing time in Sing-Sing.

$22.95 – Hardcover – 978-1-56980-333-2
$16.95 – Paperback – 978-1-56980-153-6

THE LIFE AND TIMES OF LEPKE BUCHALTER: AMERICA'S MOST RUTHLESS RACKETEER
Paul R. Kavieff

This is the first biography of the only organized crime boss to be executed in the United States. At the height of his power, Louis "Lepke" Buchalter had a stronghold on the garment, banking and flour tracking industries. As the overseer of the killing-on-assignment machine known as "Murder Inc.," his penchant for murder was notorious. This impeccably researched book traces the story from childhood, through the incredibly sophisticated rackets, to his ultimate conviction and execution. All the names, dates and brutal murders are described here, in a unique history of labor unrest in turn-of-the 20th century New York. In the end, it was an obscure murder that led to his conviction and execution.

$16.95 – Paperback – 978-1-56980-517-6

THE MAFIA AND THE MACHINE: THE STORY OF THE KANSAS CITY MOB
Frank R. Hayde

The story of the American Mafia is not complete without a chapter on Kansas City. "The City of Fountains" has appeared in the **The Godfather**, **Casino**, and **The Sopranos**, but many Midwesterners are not aware that Kansas City has affected the fortunes of the entire underworld. In **The Mafia and the Machine**, author Frank Hayde ties in every major name in organized crime—Luciano, Bugsy, Lansky —as well as the city's corrupt police force.

$16.95 – Paperback – 978-1-56980-443-8

THE PURPLE GANG: ORGANIZED CRIME IN DETROIT 1910-1946
Paul R. Kaveiff

In Prohibition era Detroit, a group of young men grew in power and profile to become one of the nation's most notorious gangs of organized crime. **The Purple Gang**, as

they came to be called, quickly rose to power and wealth leaving law enforcement powerless against the high-profile methods of the gang. During the chaos of the Prohibition era, the fearless "Purples" rose to the highest ranks of organized crime and then shattered it all with bloodthirsty greediness and murderous betrayal.

$16.95 — Paperback — 978-1-56980-494-0

THE RISE AND FALL OF THE CLEVELAND MAFIA
Rick Porrello

This is the fascinating chronicle of a once mighty crime family's birth, rise to power, and eventual collapse. The Cleveland crime family comprised of the notorious Porrello brothers, was third in power after New York City and Chicago, had influence with mega-mobsters like Meyer Lansky, and had a hand in the development of Las Vegas. At center stage of this story is the Sugar War, a series of Prohibition gang battles over control of corn sugar, a lucrative bootleg ingredient.

$16.95 — Paperback — 978-1-56980-277-9

THE SILENT DON: THE CRIMINAL UNDERWORLD OF SANTO TRAFFICANTE JR.
Scott M. Deitche

For thirty years he was Tampa's reigning Mob boss, running a criminal empire stretching from the Gulf Coast of the U.S. into the Caribbean and eventually, the island paradise of Cuba. After the fall of Batista and the rise of Castro, Santo Trafficante, Jr. became embroiled in the shadowy matrix of covert CIA operations, drug trafficking, plots to kill Castro and ultimately, the JFK assassination. Trafficante's unique understanding of the network of corrupt politicians, heads of

state, non-traditional ethnic crime groups, and the Mafia enabled him to become one of the pivotal figures in the American Mafia's powerful heyday.

$16.95 — Paperback — 978-1-56980-355-4

THE VIOLENT YEARS: PROHIBITION AND THE DETROIT MOBS
Paul R. Kavieff

In **The Violent Years**, author Paul Kavieff has once again masterfully fused the historical details of crime in Detroit with the true flavor of the Prohibition era. For those found with new prosperity after World War I ended, it became a status symbol in Detroit to have one's own personal bootlegger and to hobnob with known gangsters. Numerous gangs scrambled to grab a piece of the profit to be made selling illegal liquor which resulted in gruesome gang warfare among the many European ethnic groups that were involved.

$16.95 — Paperback — 978-1-56980-496-4

THIEF! THE GUTSY, TRUE STORY OF AN EX-CON ARTIST
William Slick Hanner with Cherie Rohn

William "Slick" Hanner delivers action-packed drama just as he lived it: as an outsider with inside access to the Mafia. Here's the gutsy, true story of how a 1930s Chicago kid with street smarts and a yearning for excitement catapults into a crime-infested world. Cherie Rohn details all of the hilarious, aberrant, exhilarating details of Hanner's adventures in this sharp, insightful biography about secrets of the Mafia.

$22.00 — Hardcover — 978-1-56980-317-2

BARRICADE BOOKS TRUE CRIME

For more information, contact:
Jonathan Bernstein at 516-647-3590 or
Email: jonathan@barricadebooks.com
Order through your National Book
Network rep or directly from:
National Book Network
15200 NBN Way
Blue Ridge Summit, PA 17214
Customer Service: 1-800-462-6420
Email: Custserv@nbnbooks.com
Fax: 1-800-338-4550